THIRSK &
SOWERBY

From Old Photographs

A Second Selection

COOPER HARDING

AMBERLEY

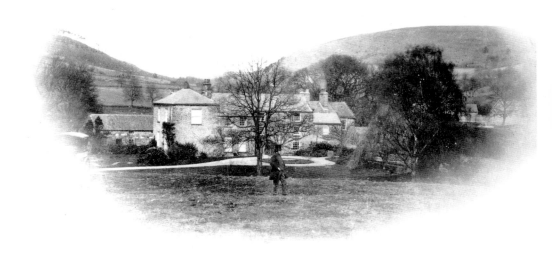

Manor House at Kirby Knowle in the late 1860s, judging from the costume of the gentleman in the top hat.

First published 2003.
This edition published 2011.

Amberley Publishing
The Hill, Stroud
Gloucestershire, GL5 4EP

www.amberley-books.com

British Library Cataloguing in Publication Data.
A catalogue record for this book is available from the British Library.

ISBN 978 1 4456 0670 5

Typeset in 10pt on 12pt Sabon.
Typesetting and Origination by Amberley Publishing.
Printed in the UK.

Contents

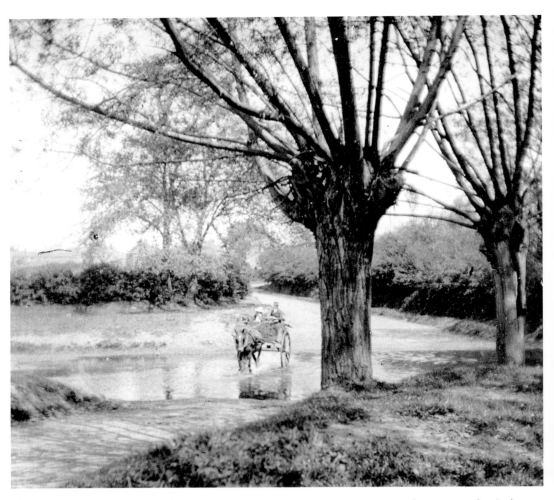

The ford at World's End, Sowerby, *c.* 1905. Mother and daughter in a pony and trap cross the Cod Beck at this picturesque spot at the far end of Sowerby. The pollarded willows are typical of the area, providing the essential material for basket-making.

Introduction

Since Dr Peter Wyon and I put together a first selection of photographs in 1995, three celebratory occasions have led to a greatly increased interest in the photographic record of the town and its inhabitants. 1998 was nominated as the Year of the Photograph, and as our contribution Thirsk Museum mounted a major exhibition of the work of local photographer Joseph Robinson Clarke. Clarke was born and brought up in Stockton-on-Tees where he joined his father and brother in an early photographic business, but wishing to set up on his own he came to Thirsk in 1870 and opened a studio, first on St James' Green, then in what was little more than a wooden shack off Ingramgate on the bank of the Cod Beck. His early photographs are standard carte-de-visite or cabinet portraits, posed in his studio with a few pieces of furniture and other props against painted backcloths. The development of the dry-plate process and the reduction in exposure times freed the photographer and his subjects from the constraints of the studio, and from the 1890s onwards we find Clarke working out of doors. The busy world of the weekly market, the frequent parades and processions of church and chapel organisations, visiting dignitaries, military manoeuvres, fairs and circuses, these all offered subjects for his lens. The more people in the crowd, the more copies he could sell. Clarke was the first person in Thirsk after Squire Bell to own a motor car, and this took him out into the countryside, to the big houses and their estates. Quite without realising it, Clarke was an excellent recorder of the social history of his time and many of the photographs included here are his work. The business was carried on through the 1930s by his son, who was still taking wedding pictures in the town in the late 1940s. The Clarke studio, reduced to a garage store-shed, survived until the 1980s.

The year 2000 stimulated communities large and small to mark the occasion by putting together a record of their town or village, past and present. In many cases the researchers were able to track down photographs and documents that had lain neglected for decades, while family albums were pulled out of cupboards and memories cudgelled for names and places. The availability of substantial grants of money to fund research and publication led to the production of a number of books of considerable merit. The photographic collection at Thirsk Museum played a useful role in providing material for this work locally and benefited by a number of eventual additions to its archive.

Thirdly, hard on the heels of millennium celebrations, came the Golden Jubilee of our present Queen Elizabeth II. Among the other events taking place, the museum mounted a photographic exhibition of Thirsk and district during the

1940s and '50s. This period was poorly represented in the museum's collection and appeals for suitable material eventually produced some interesting pictures, including some hitherto unknown and unofficial photographs of the Canadians serving with bomber squadrons based on local airfields. Strangely, two events of the 1950s appear to have passed unrecorded in Thirsk; there seems to be nothing to show how, or even whether, the town celebrated the Festival of Britain in 1951. Similarly, we have found very little to show the events of coronation year, 1953. We have found one picture of a procession through the Market Place, but nothing to match the junketing of 1902 or 1911.

The majority of the photographs in this selection are drawn from the work of Clarke and other local photographers of his time. The first twenty years of the last century were the golden age of the picture postcard and the family portrait, which have survived in considerable numbers, but collectors are at work and good cards of that period are becoming harder to find and certainly more expensive to buy. Fortunately for the collection available to us, the Civic Society of Thirsk, anxious about the future of the town centre and apprehensive of the effects of the A19 bypass which was opened in 1972, commissioned a photographic survey of all the premises around the Market Place. Those photographs now form an archive in themselves and enable us to see how much has changed in the generation since those shots were taken in 1970. Change there has been and it seems to be accelerating at present. The last working saddler in the district has shut up shop and retired. The oldest plumbing business in the district has closed. Nursery Gardens is today the name of a residential complex on the site of the greenhouses behind the Three Tuns where half of the former inn yard has gone for development. The magistrates no longer sit in the Court House. The old and admittedly derelict King's Arms has been demolished, while the complex of eighteenth-century farm buildings in Masonic Lane has been converted for housing and the old fire station disappeared overnight. But for all the regrets about what has gone, there is much to be pleased about. Many of the recent developments deserve praise; the town is growing, there has been a revival of light industry and the town is benefiting from the Market Town Initiative scheme. This present selection of photographs by its very nature reflects the past, but nostalgia has its limits, and while being mindful of our history, we should be looking to a future worthy of the past.

All photographs are from the Thirsk Museum collection unless acknowledged otherwise.

Note to the second edition: I have taken the opportunity offered by this reprint to correct several errors found in the original edition, to add names in a couple of photographs and to bring details up to date in those places where we have been overtaken by recent developments.

JCH – September 2011

I

Market & Town

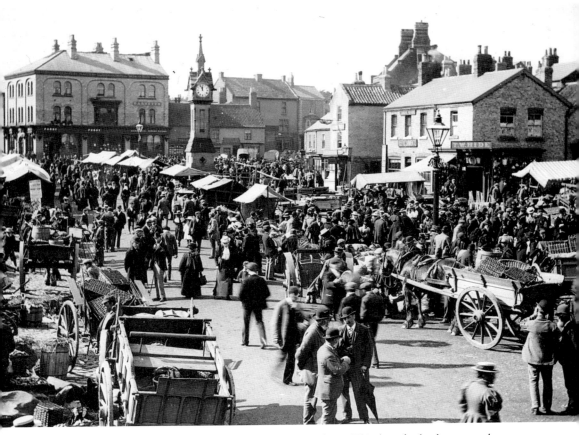

Thirsk Market Place, *c.* 1900. Monday has been market day in Thirsk as far back as records go. Seen at midday, the market is in full swing; there are traps and carts in the foreground and a couple of gypsy caravans in the top left corner of the picture.

The Market Place stands at the heart of the town. Its layout is medieval in plan, but may well date from the Norman period when trading seems to have been moved from the Saxon settlement on the east side of the Cod Beck to a site outside the ramparts of the castle built on the western bank of the river. It has been suggested by historians that the Market Place represents the former outer bailey of the Norman stronghold. The existing buildings that line the square stand on the medieval frontages with long, narrow garths and crofts behind them. In time these strips of land were crammed with barns, stables, outbuildings, workshops, warehouses and cottages, forming the famous 'yards' of Thirsk, clearly seen in the right upper section of the photograph below. Overcrowded and insalubrious, most of the yards have been cleared of buildings and opened up for rear access and parking. One or two remain to add a picturesque reminder of former days.

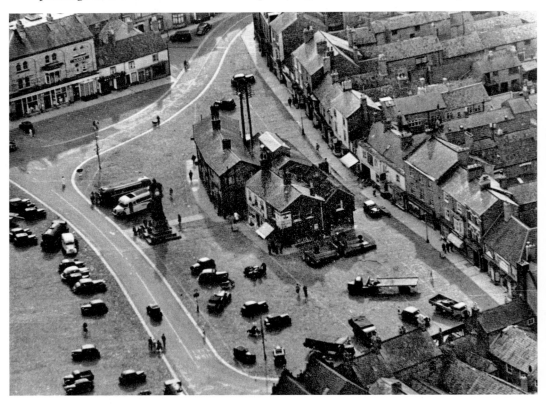

Thirsk Market Place in the 1940s. This unusual aerial view of the market place is difficult to date but the comparatively small number of parked vehicles suggests a period in the 1940s. The central block of buildings includes the post office and sorting depot built in 1909, replacing a row of ancient shops which marked an early encroachment on the open ground of the market site. At the top of the picture Kirkgate swings northwards towards St Marys church; at the foot of the photograph the road runs down to Finkle Street and the bridge over the beck. The cars on the left are parked in front of the Golden Fleece Hotel.

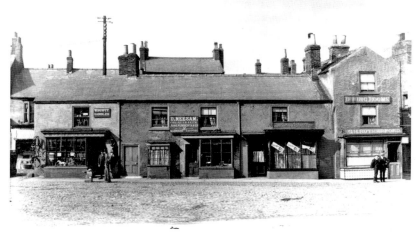

Shops in the Market Place, *c.* 1905. This row of old shops in the centre of the Market Place once had thatched roofs and was in a dilapidated state towards the end of the nineteenth century. By 1905 they had been repaired and re-roofed, though the chimney pots are still leaning oddly. On the left is Scott's saddlery, established in 1870, while round the corner can be seen some of the wares from tinsmith Robert Bolton. In the centre is D. Neesam, cabinetmaker, joiner and undertaker; his sign declares 'All orders executed'. Thompson's millinery next door is announcing a clearance sale. The three-storey building on the right was Rutherford's Dining Rooms, a busy eating house on market day. These shops were all demolished in 1908 to make way for a new head post office.

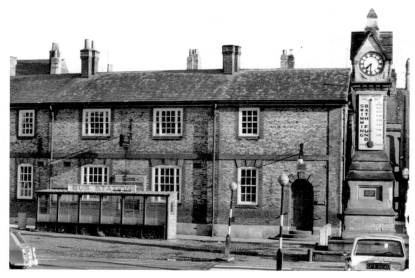

Thirsk head post office, 1970. This building was erected in 1909 on the site of the old shops seen above. At the rear was a sorting office from which postmen once went off in pony and trap to outlying farms and villages. This picture also shows the rather unsightly bus shelter which stood outside the post office until the 1990s, when the office was closed and converted into retail units. Note the thermometer on the clock tower recording the progress of the Swimming Bath Fund.

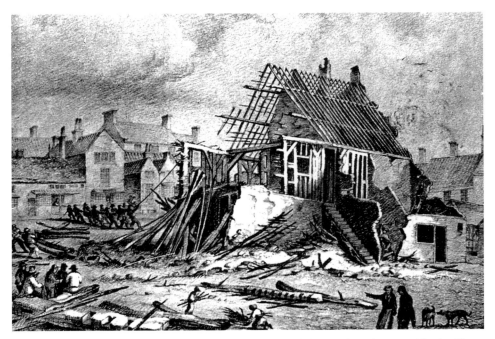

The Tollbooth or Market Hall stood on the south side of the Market Place outside the Fleece Hotel. It was a timber-framed building and would have had an open arcade at street level to shelter market traders, while a room on the first floor housed the Manor Court and served as a Sessions House for the Justices of the Peace. At a later date the ground floor was enclosed and by the end of the eighteenth century, when the Quarter Sessions were moved permanently to Northallerton, the Tollbooth ceased to serve as a court room. In the early nineteenth century it was used from time to time as a theatre and in 1834 it was burnt out when fire spread to it from the booth of a travelling showman. The ruins were demolished and it was never rebuilt. This drawing of the demolition work in progress was made by nineteenth-century Thirsk artist Bartholomew Smith.

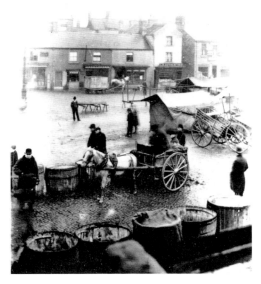

The end of a particularly wet market day seen from a first-floor window on the south side of the square. The bowler-hatted figure huddled in a great-coat on the left is George Gill, bellman or town crier, with his bell clasped in his left hand. Gill, sausage-maker by trade, was a well-known character in the town at the end of the 1890s. His portrait in oils hangs in the museum. The official bell was confiscated by the police in 1940 when invasion was expected and was not recovered until some time after the end of the war. It is now kept in Thirsk Hall.

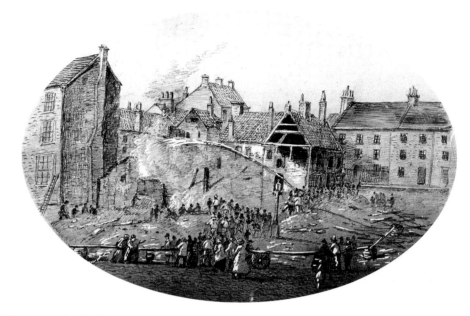

This sketch by Smith features an incident in May 1864 when the premises of John Baker were destroyed by fire. Leading members of the Quaker community in the town, the Baker family were drapers by trade and lost both home and business. Their son, John Gilbert Baker, had recently published a book on the botany of the North Riding. Having lost his stock of copies in the fire, he took a post at Kew Gardens, becoming a noted Keeper of the Herbarium. There is a plaque to his memory in the alley which bears his family name.

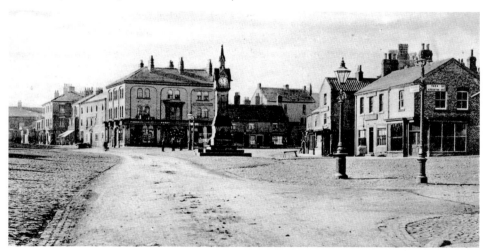

This view of an unusually deserted Market Place is taken from the corner of Finkle Street, looking west towards the large building that replaced Baker's premises after the 1864 fire. Occupied in the early twentieth century by Richard Purdy's ironmongery business, succeeded by H. Reddin & Sons, it was later taken over by the National Provincial Bank and is now the Thirsk branch of NatWest. Two features enable this picture to be dated between 1904 and 1908. The earlier date marks the introduction of electric lighting to the town and the new standard can be seen on the right, next to the old gas lamp; on the other hand, the old shops beyond are still standing – they were demolished in 1908.

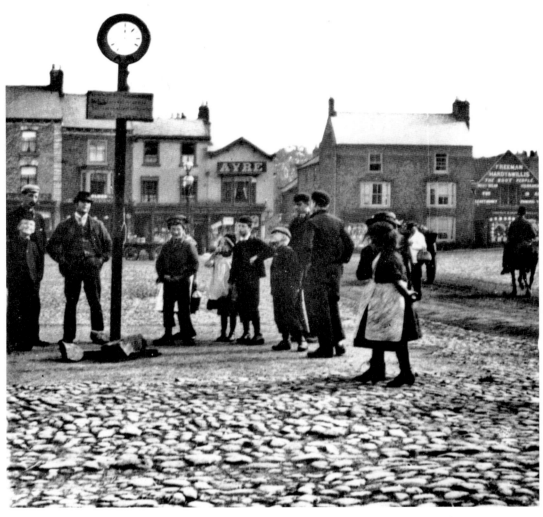

The dummy market clock, 1895. In 1893 the Duke of York married Princess May of Teck, later coming to the throne as King George V and Queen Mary. The people of Thirsk thought that the wedding of this royal pair should be celebrated by a suitable memorial and finally agreed to the erection of a tower clock and drinking fountain to replace the stump of the old market cross. Initial contributions came to £62, but further money was slow to come in, and by 1895 the project had not advanced. One night a group of jokers set up a scaffold-pole with a clock face painted on a barrel lid and a notice which read 'No tick here!' The good folk of Thirsk took the hint, the remaining cash was collected and the market clock was built. It soon became the focus of activity in the town and is its best-known landmark.

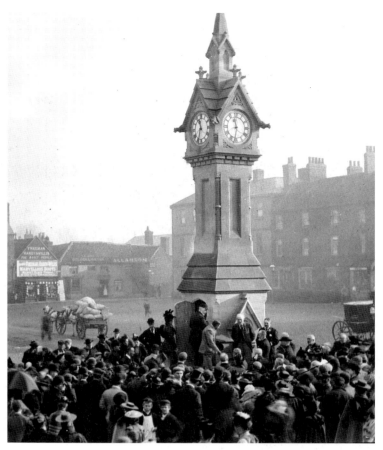

A box of old lantern slides found in the vicarage attic provides a previously unknown picture of the inauguration of the market clock in 1896. The decorative finials on the gables over the clock face did not stand the test of time and have long since vanished. The pinnacle, too, had disappeared by the 1920s, though whether by accident or by mischief is now unclear.

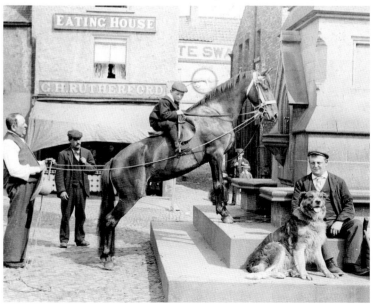

There never seems to have been a horse trough in Thirsk Market Place; with water available in all the inn yards, it was perhaps thought unnecessary. The clock tower incorporated a drinking fountain for thirsty humans and a trough for dogs. The spirit of mocking reproach that prompted the setting up of the dummy clock seems to have inspired this posed shot. The characters involved are not named but were no doubt easily recognised!

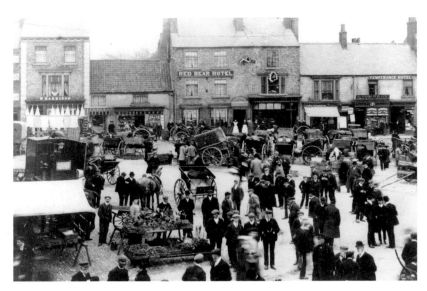

The north-west corner of the Market Place, *c.* 1900. The first shop on the left is Harrison's drapers, with a stationery department in the low building next door. The Red Bear is divided by an alleyway from Kemp's milliners. On the right are premises owned by John Thomas Fox who combined shop-keeping with press reporting. The left-hand side was his Music Warehouse, while the larger part of the building is advertised as a temperance hotel, with 'good beds – commercials & cyclists supplied'. Behind the awning of the stall in the left foreground is a sign of the times – 'Motorists Stop Here'.

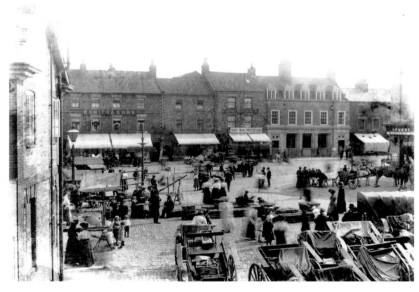

Some ten years later than the view above, this photograph seems to have been taken from the first-floor window of Fox's shop, looking over to the south side of the Market Place. The wall on the extreme left is the newly erected head post office, while across the square the awnings are out over the windows of B. Smith & Son, drapers and outfitters, and those of Foggitt's chemist's. Next to the carpet warehouse with its sale in progress is Barclays Bank, which had recently been rebuilt in the neo-Georgian style that was to become the fashion for banking premises.

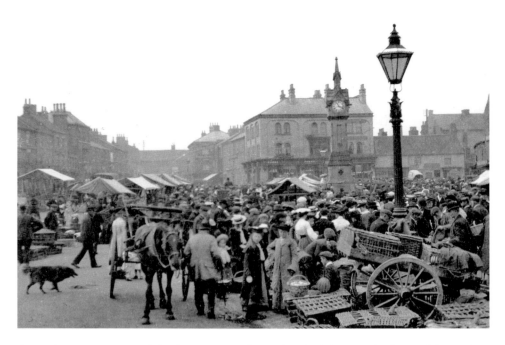

A very busy moment on a Monday in 1901. The market clock became the focus of the trade in eggs and poultry, which can be seen in the baskets in the right foreground of the picture. There was brisk dealing here between farmers' wives and buyers from the West Riding who supplied the Jewish communities of the clothing industry in Leeds and Bradford.

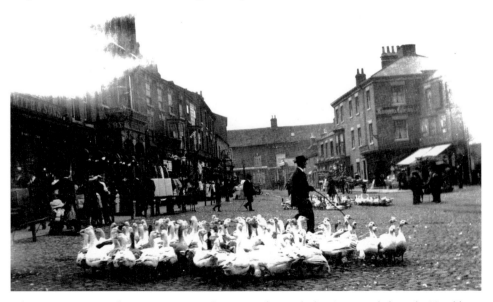

'Christmas is coming, the geese are getting fat!' Long after cattle droving ceased along the Hambleton Hills, flocks of geese were still brought into Thirsk in the years before the First World War. If old accounts are to be believed, birds that had come from a distance were 'shod' for the journey by being driven through a pool of tar and then through sand to form a protective skin on their feet.

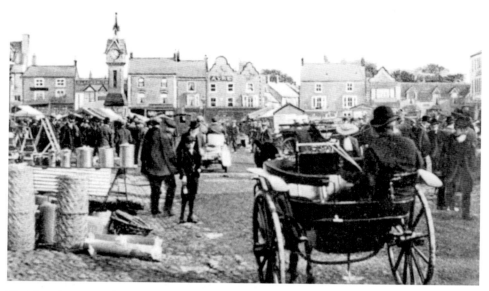

The changing pace of transport, *c.* 1902. The pony and trap in the foreground is preceded by a motor car bearing an AK registration. We are looking east towards Ayre's grocer's and chemist's with the stylish Dutch gables which were added in 1901. The wares set out on the left belong to Richard Purdy's ironmongery store.

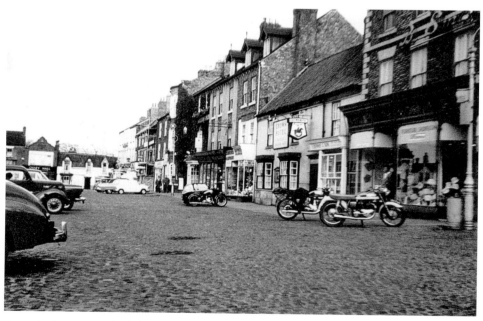

By 1961 the motor vehicle had long displaced the pony and trap. This shot of the south side of the Market Place features two well-loved buildings that were soon to be demolished. The shop windows on the right are those of the renowned drapery business of B. Smith and Sons. Next to Smith's stands the Crown Inn, the oldest of the three posting houses which served the busy coaching traffic passing through the town. (*Mo Penson*)

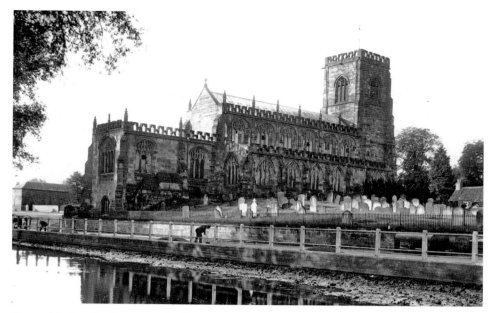

The parish church of St Mary is by far the finest building in Thirsk. Built in the Perpendicular style between 1430 and 1480, it replaced an earlier Norman church, which was itself probably set on a Saxon foundation. The tower is a landmark visible from all the roads leading into the town, and St Mary's stands high above the Cod Beck flowing down towards the town centre. Until the 1950s the mill dam ran past the church, the surface acting as a mirror for the medieval architecture above.

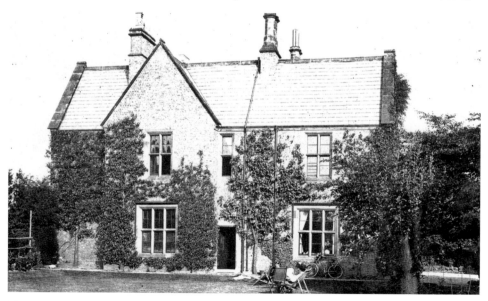

This is a rare photograph of the vicarage, built in 1851 to replace a dilapidated cottage that stood in Norby, north of the church. A century later the Victorian parsonage was replaced by modern, if undistinguished, house. A few years back this was demolished in its turn to give way to a more comfortable dwelling, while further houses now occupy the once extensive garden and stable yard. (*Ray Ballard*)

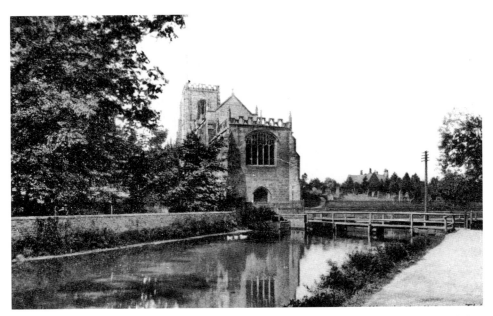

This view of the east end of St Mary's at the end of the nineteenth century shows the mill dam running along the wall of the Marage, the strangely named ornamental water garden which faced Thirsk Hall. The footbridge gave access to the church from the footpath that ran between the dam and the Cod Beck. The roof of the old vicarage is just visible above the trees to the right of the church. The bridge has now gone and Marage Road runs along the line of the footpath. (*Ray Ballard*)

Taken a few years after the view above, this one looks towards the top end of Kirkgate, with Thirsk Hall in the background. The footbridge across the mill dam can be seen on the left; the two lamp standards fix the date between 1904 when electric street-lighting was installed and 1914 when the disused gas lamps were finally removed. The cows may have come from Barley's farmyard further down Kirkgate, where milk was on sale into the 1920s. (*Ray Ballard*)

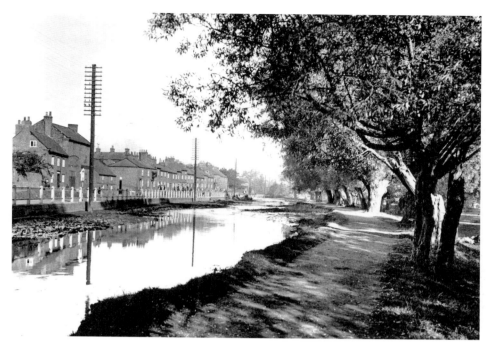

Norby is an ancient settlement with a Danish name, which grew up just outside the town limits, forming a compact community of ancient cottages and yards on the west bank of the Cod Beck. The houses fronted on the highway from Thirsk to Northallerton which skirted the mill dam, beyond which was a plantation of ancient pollarded willows known as the Holms. Pleasant though the prospect may have been, Norby was overcrowded, the dwellings in poor repair and sanitation practically non-existent. The old cottages were demolished wholesale in the mid-1950s to be replaced by modern council housing, while the mill dam was filled in and grassed over to form a beck-side recreation area.

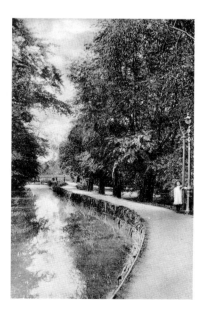

The Holms, lying in Norby between the mill dam and the beck itself, was a favourite promenade for the folk of Thirsk and is the subject of many postcards. The willows planted in this area served to provide withies, the pliable stems used in basket-making, one of the principal crafts in Norby in the days when baskets of all shapes and sizes were in constant demand. The area is still popular today as a playground and picnic site.

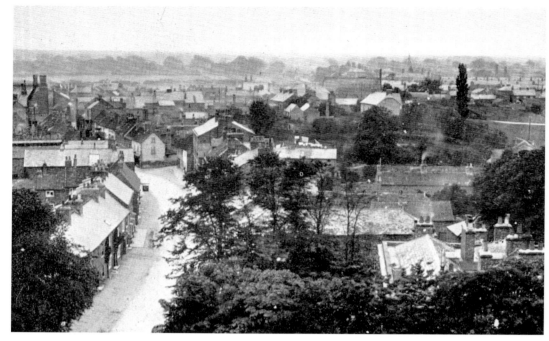

This unusual view of Kirkgate from the top of St Mary's tower probably dates from the 1920s. The photographer may have taken advantage of the general custom of opening church towers to the congregation on Ascension Day, a practice less common in our modern safety-conscious culture. Kirkgate, known earlier as St Marygate, is one of the oldest thoroughfares in the town, linking the precincts of the Norman castle with the church and the manor house. The trees in the foreground stood in the gardens of Thirsk Hall, the roofs and chimneys of which appear on the right. The large house further down on the right of the street was, until the 1940s, the residence of various doctors until taken over by Donald Sinclair for his veterinary practice, later to be made famous by his partner Alf Wight as the James Herriot surgery. The row of cottages on the left has fruit trees trained against the wall, once a feature of the town which, we are told, was famous in London clubs for apricot jam.

Opposite: The Electric Shop in Kirkgate across the street from Lord's birthplace was managed by Eric Thompson, a noted Thirsk personality. He was a passionate local historian and assembled a collection of notes which formed the basis of *My Book of Thirsk*, published in 1947, a very useful source book on the development of the town during the late nineteenth century and the first part of the twentieth. The shop is now an art gallery.

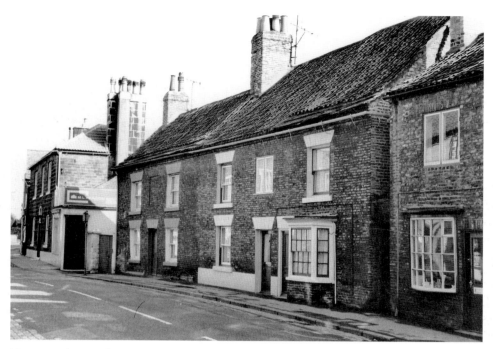

Nos 14 and 16 Kirkgate, seen in 1970, originally formed a single house, timber-framed with a thatched roof and beaten-earth floor, later refaced in brick and enlarged. In 1755 a son Thomas was born here to a labourer named William Lord. In later life Thomas made a name for himself as a cricketer with a London club and was commissioned by the members to find land that could be used as a cricket ground. Tom Lord's cricket ground became the home of the MCC and has borne his name ever since. The building in Kirkgate now houses Thirsk Museum.

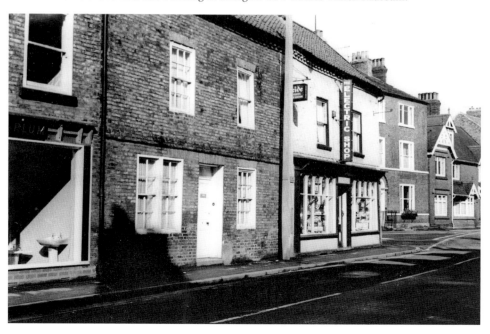

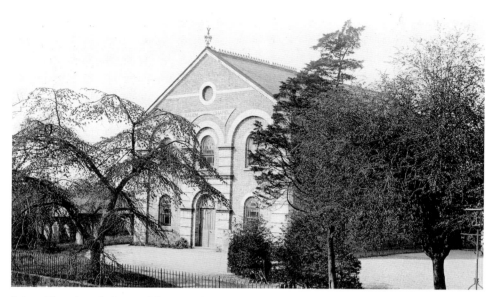

Salem Chapel, early 1900s. This was the place of worship of the Independents, later known as Congregationalists. The earliest meetings of the Independents were held in the Tollbooth, but by 1804 they had a chapel in the Back Lane which soon became known as Chapel Street. In 1845 a handsome new chapel was built at the bottom of Finkle Street, the site on the west bank of the Cod Beck having been given by John Bell, squire of Thirsk. Attached to the chapel, which was named Salem, was a small burial ground and an infant school. (*Ray Ballard*)

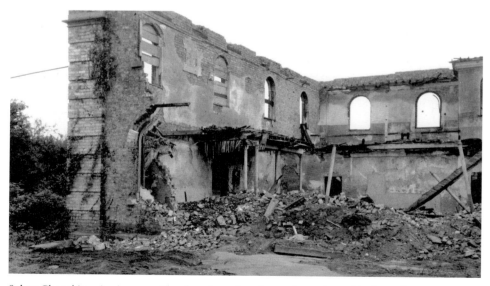

Salem Chapel in ruins in 1991. The chapel continued as a place of worship for well over a century, but a dwindling congregation could not meet the costs of upkeep and the chapel closed. It served for some time as a storeroom but in 1988 was gutted by a spectacular midnight blaze. The ruins stood until 1991 when the remaining structure was declared unsafe and demolished. The site was sold for housing, but the burial ground remains and has now been laid out as a sensory garden in which are set the few remaining headstones. (*Ray Ballard*)

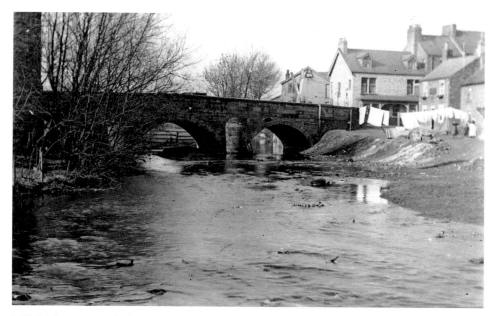

Mill Bridge, 1950s. The bridge at the end of Millgate carries traffic from the Market Place into St James' Green and out to the main York road. The wall visible on the left of this picture was that of the great Town Mill owned by the Rymer family and, until milling ceased after the war, an important local business. The cottages on the right, with washing drying on the river bank, were part of Waterside, a group of dwellings that regularly suffered from seasonal flooding of the beck. They were demolished in the early 1990s and replaced by housing set (hopefully!) above flood level.

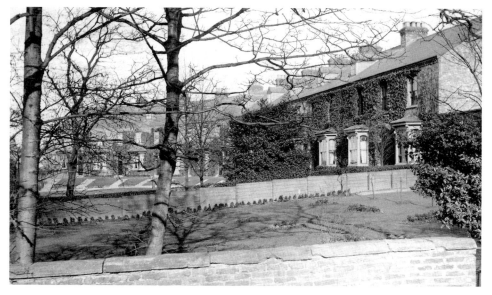

The Crescent is an elegant terrace of Victorian houses built between Ingramgate and St James' Green, with private gardens sloping down to the beckside on land once part of the grounds of Ingram House, a mansion belonging to the Franklands of Thirkleby. The view of these houses from the bridge over the beck is now much obscured by trees and shrubs.

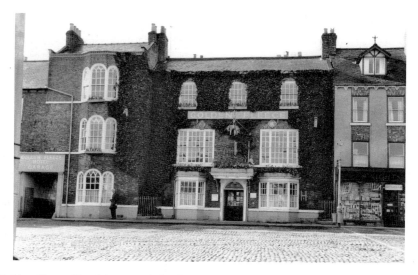

The Golden Fleece Hotel is one of the former posting houses serving the coaching trade on the important route from York to Newcastle and Edinburgh. For many years it was owned by William Hall and was known generally as 'Hall's Fleece'. There was stabling in the yard for sixty horses providing relays for stagecoaches and for drawing the gigs and carriages that were hired out to travellers. When the railway came, the Fleece ran a horse-bus to carry passengers the mile or so between the town centre and station. As patterns of travel and recreation changed, cyclists and motorists were added to its clientele. The frontage remains unchanged today, save for the absence of the creeper on the walls.

The Brewer's House, Kirkgate, 1970. The house was built in the early nineteenth century for William Rhodes whose Kirkgate brewery was one of four in Thirsk. Beer was in great demand; in the 1890s there were a dozen public houses on the Market Place and altogether thirty licensed premises in the town. Brewing ceased at Kirkgate brewery in 1897 when the business was taken over by John Smith of Tadcaster and reduced to a bottling plant. An off-licence operated in the small premises by the gateway. In 1970 the site served as a builder's yard; the remaining premises have been converted into flats and the chimney stands as a memorial.

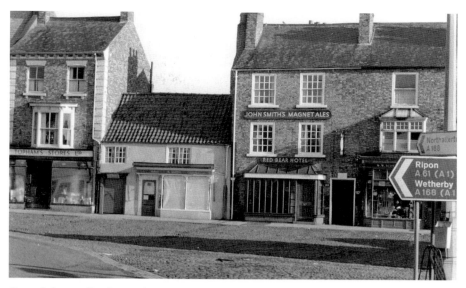

One of the smaller licensed premises on the Market Place, the Red Bear was in existence by 1823. There was much indignation locally when, after a major refurbishment in 1997, the name was changed to The Darrowby Inne. The change coincided with the opening of a new James Herriot attraction in the old vet's surgery in Kirkgate and was clearly aimed at catching the Herriot Country tourist trade by adopting the name of the fictitious town featured in the television series *All Creatures Great and Small*. Thirsk protesters sniffed victory when the offending sign was taken down, but success was not to be theirs – the only change was to reduce 'Inne' by removing its superfluous final 'e'!

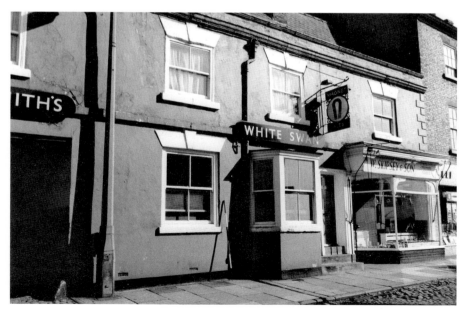

The White Swan was another modest public house on the north side of the Market Place and had at one time been a commercial hotel. The shop next door was a greengrocer's. Woollon's hardware store now occupies the whole building.

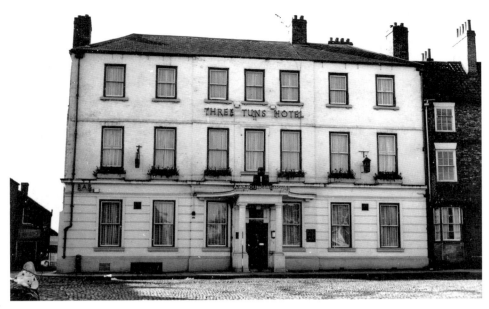

The Three Tuns Hotel disputed with the Golden Fleece the position of leading coaching inn in Thirsk. For many years at the turn of the eighteenth century it was run by Mrs Alice Cass, and it was here that William Wordsworth and his sister Dorothy stayed overnight on their long walk across the moors to meet William's fiancée, Mary Hutchinson, whose family lived near Scarborough. The Three Tuns has a fine interior with a magnificent staircase dating from its earlier use as the Dower House of the Bell family.

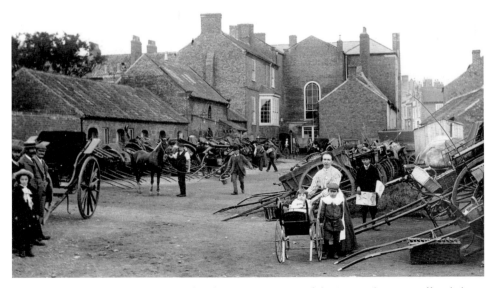

The yard of the Three Tuns on a market day, *c.* 1900. Most of the inns and taverns offered cheap stabling during the day for the horses and ponies that brought folk into town and there was plenty of room here to park traps and gigs. The larger part of this yard was sold off a few years back and has been developed for housing.

The King's Arms stood at the lower end of Kirkgate. It was a large, rambling building with a yard backing on to Castle Garth. There was a brewhouse and a number of old cottages reached through a narrow passage behind a single door leading on to the street. For some thirty years at the turn of the nineteenth century the King's Arms was run by Grace Maria Wain, a widow who had taken over the licence from her mother. After Mrs Wain's death the property was inherited by one of her employees, but it decayed steadily over the years and when this picture was taken in 1970 it was already sadly dilapidated. It was finally demolished in 1999, to be replaced by a thoughtful redevelopment of the site.

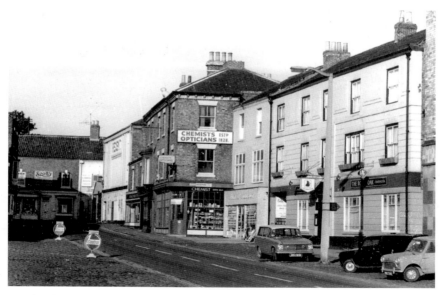

The Royal Oak was another pub backed by an extensive yard; an eighteenth-century document refers to the existence there of Cockpit House. Certainly cockfighting was popular in the district in the 1780s. The Royal Oak was still licensed in the early 1990s, but the sign that ran across the frontage has now gone and the building has been adapted to provide retail, office and living accommodation.

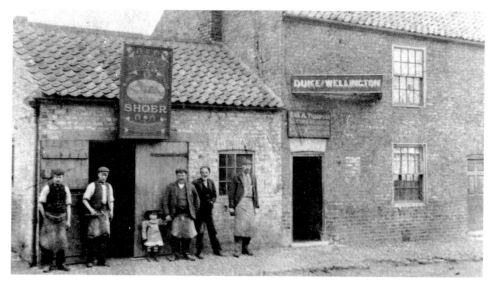

The Duke of Wellington, 1907. In the middle years of the nineteenth century this public house on the east side of Long Street was licensed to Thomas Peacock and his successors as the Waggon & Horses but it became the Duke of Wellington when Thomas and Dorothy Trenholme took over in the 1880s. Their successor was Robert A. Thompson who combined innkeeping with his trade as a blacksmith. Above are Robert, his son and mates, at the door of the smithy wearing the leather aprons of their craft. The child may be daughter Edith. (*Ray Ballard*)

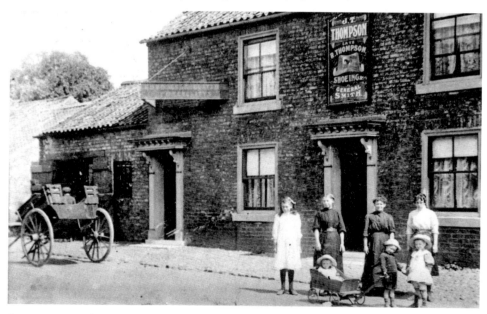

Some ten years later the shoeing business was in the hands of Robert's son, John Thomas. The smithy remains as before, but the pub was abandoned in 1909 in favour of the bed-and-breakfast trade; the former inn sign reads 'Good accommodation for cyclists'. The house has been improved, with elaborate door cases added, while the sash windows have been modernised. It still stands as a private dwelling today, though much altered. (*Ray Ballard*)

2

Commerce & Industry

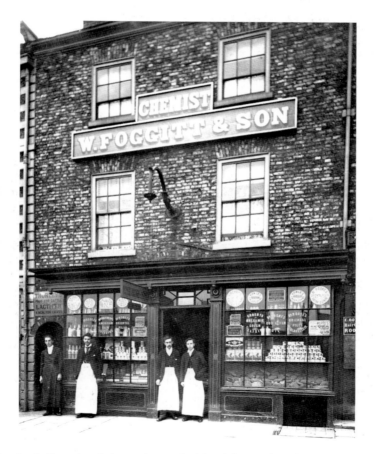

William Foggitt & Son, chemist's, on the south side of the Market Place, *c.* 1900. The first of the Foggitt chemist's set up business in Thirsk in 1836 and the shop passed down through three generations before being acquired by Boots who trade on the same site today, though the building seen here was replaced by modern premises in the 1960s.

The number and diversity of small family shops was characteristic of market towns like Thirsk throughout the nineteenth century and the first half of the twentieth. In many cases the family lived 'over the shop'. The disappearance of these small concerns and the abandonment of the first and second floors as living quarters since the end of the Second World War has had a marked effect on the life of the town centre. Efforts are now being made to bring some of these former homes back into occupation, though the family businesses to which they belonged have sadly gone for good.

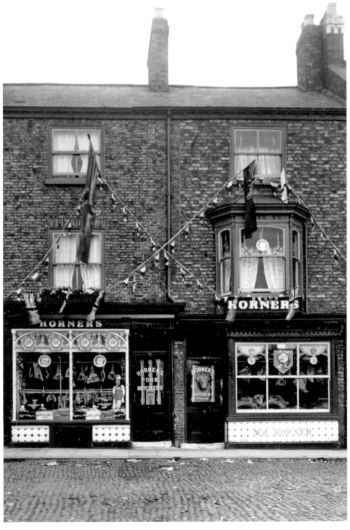

The decorations put up to celebrate the coronation of George VI in May 1937. The premises are those of William J. Horner on the north side of the Market Place. The traditional distinction made between pork butchers and those dealing in beef and mutton is not so commonly observed today, but it was firmly maintained here by Horner with two separate shops. The display in the left-hand window is particularly interesting. (*N. Smith*)

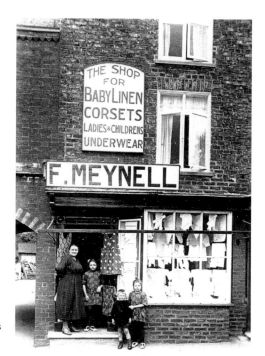

Fred Meynell's shop first opened at Town End in rather cramped quarters on the north side of Westgate. Seen in the 1920s are Fred's wife Una, her niece Joyce, her daughter, also Una, and her son Errol (known to all as 'Sonny'). (*M. Meynell*)

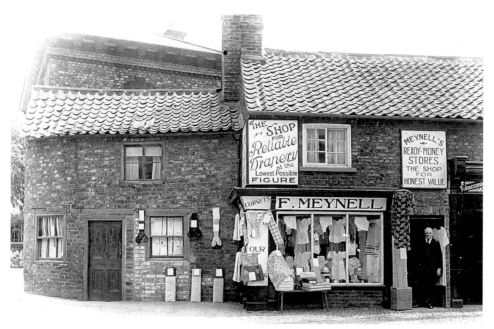

Fred Meynell later acquired larger premises just across the road on the Sowerby side. Here he is in the doorway of the new shop with goods displayed in typical profusion both in the window and outside. The large building behind Meynell's shop was the police station. (*M. Meynell*)

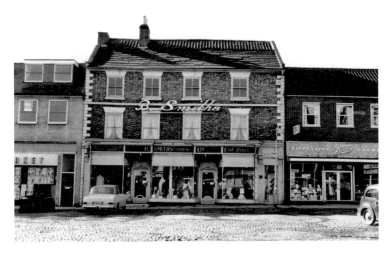

B. Smith's was one of the most famous shops in Thirsk. The first Bartholomew Smith was recorded as a maker of breeches with a stall in Thirsk Market in 1580 and the firm claimed a place for an unbroken history of trading in the *Guinness Book of Records*. The nineteenth-century Bartholomew Smith was a talented artist and neglected his drapery trade for painting; he was fortunate to find a competent son-in-law to carry on the business for him. Here the draper's store is shown in 1970 shortly before it closed down. By this time a supermarket had replaced the old Crown Inn on the left, while Boot's new building on the right had taken the place of Foggitt's.

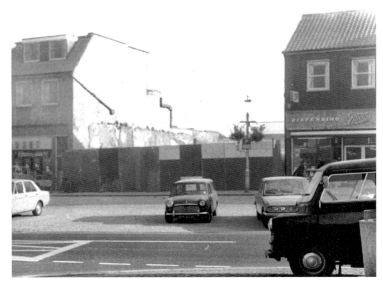

A great gap in the skyline and a wooden hoarding were all that remained of B. Smith's a few months after the previous photograph was taken. The demolition of three notable buildings on the south side of the Market Place together with proposals to replace its ancient cobbles with asphalt alerted the citizens of Thirsk to the growing threat to the architectural heritage of the town. A vigorous and successful campaign was mounted to preserve the unique features of the Market Place; the cobbles were saved and the frontages kept for the most part intact.

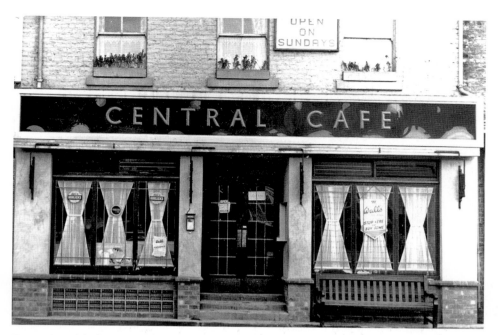

Occupying a block in the centre of the Market Place next to the post office was the Central Café, seen here in the 1940s. A popular eating place, it was well sited to catch both the market day trade and the weekend tourist. A thriving fish restaurant continues the tradition today.

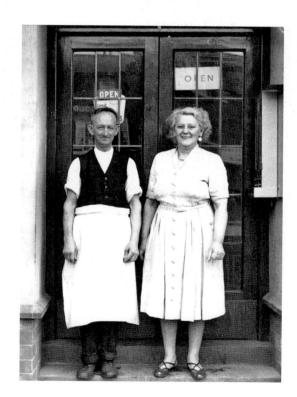

Café proprietress Dolly Dennis with assistant Arthur Hicks. The Dennis family also ran the greengrocer's shop next door.

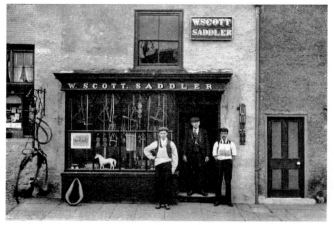

Scott's saddler's shop, *c.* 1901. William Walter Scott set up in business in 1870 in one of the old shops in the centre of the Market Place, which were demolished in 1908 to make way for the post office. William stands in the doorway accompanied by his sons George (right) and William.

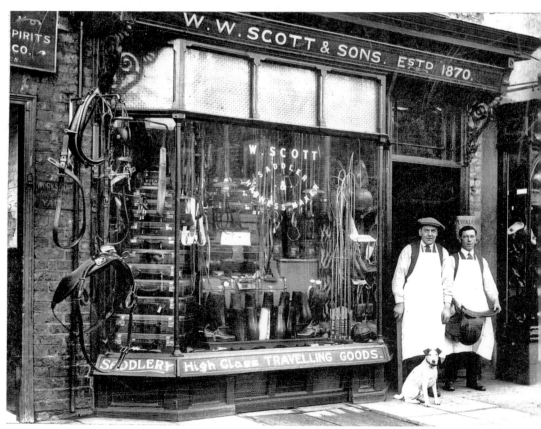

In 1908 Scott moved his business to 49 Market Place, which had previously housed Kemp's millinery establishment. George and William are seen here in the 1920s. The brass plate on the wall behind William is that of Arthur William Walker, solicitor, who occupied the first floor. He was later also the registrar of marriages; bride and groom had to go through the saddler's shop to reach the register office. Scott's, the last working saddler's in the area, finally closed in 2000. For some years the building housed the tourist information centre, but at present stands empty.

Wright's bookshop and stationery store, *c.* 1975. The founder of the firm, Zaccheus Wright, born in 1845 and known to all as 'Zacky', was in business in Thirsk by the 1870s, describing himself as bookseller, stationer and master printer. Together with B. Smith's and Foggitt's, this was one of the best-known shops in the town. Zacky Wright was also prominent in local sport and played cricket for the town XI. Wright's closed in 1988.

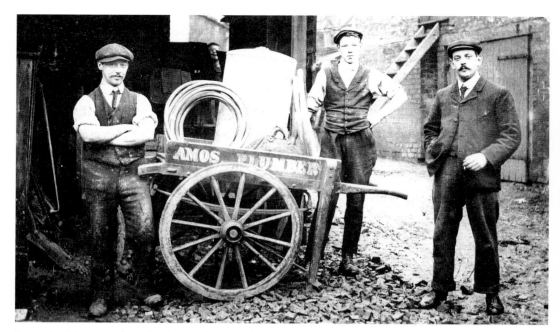

James Basil Amos (right), plumber and glazier, *c.* 1920. His father Thomas had established a plumbing business in Thirsk in the 1880s, working from a yard on St James' Green. The traditional bag of tools is stowed on the handcart. Note the pump with its long handle on the left.

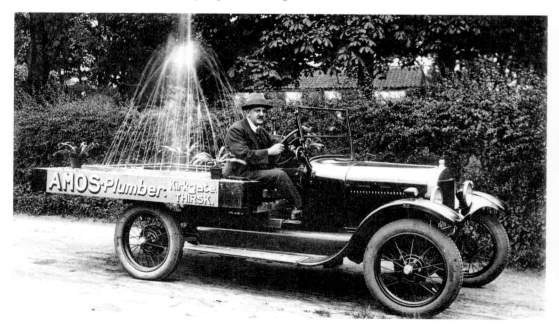

James B. Amos some ten years later when he had acquired larger premises in Kirkgate. He is at the wheel of what seems to be a very new vehicle. The car has been fitted with a working fountain to take part in one of the parades of decorated floats popular at the time. The business in Kirkgate passed in turn to son and grandson before closing for good in the late 1990s.

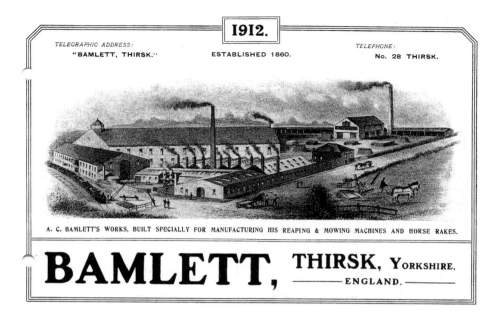

1912.

TELEGRAPHIC ADDRESS:
"BAMLETT, THIRSK."

ESTABLISHED 1860.

TELEPHONE:
No. 28 THIRSK.

A. C. BAMLETT'S WORKS, BUILT SPECIALLY FOR MANUFACTURING HIS REAPING & MOWING MACHINES AND HORSE RAKES.

BAMLETT, THIRSK, YORKSHIRE.
ENGLAND.

For over a century Thirsk was Bamlett's, so far as the world of agricultural engineering was concerned and wherever in the world there was a need for grass cutters and reapers. This print of Bamlett's works on Station Road formed the front cover of the 1912 catalogue and price list. (*Terry Barker*)

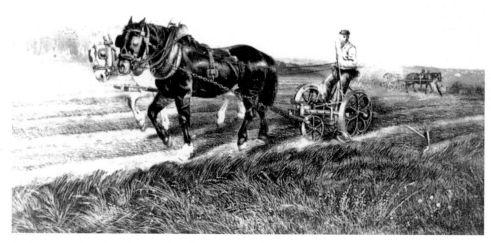

A photographic print of a painting showing an early Bamlett machine at work. This was a two-horse single-wheel-driven grass cutter. First produced in 1863, it was selling in 1872 for £25.

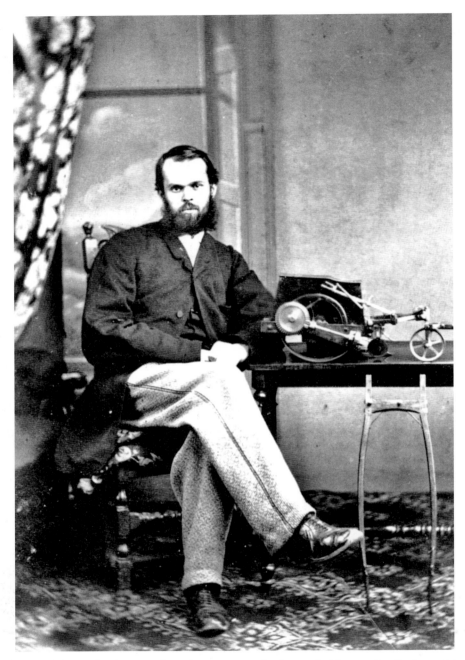

Adam Carlisle Bamlett in 1870. Born in 1835, son of a farmer in Norton, Co. Durham, Adam Bamlett showed an early interest in all things mechanical and at the age of twenty-four secured his first patent. In 1860 he came to Thirsk and set up the agricultural engineering works that made his name famous. His horse-drawn mower, efficient, reliable and cheap enough for the small farmer to buy, was exported all over the world. Surviving examples are much sought-after today by collectors and restorers of vintage farm equipment. This early studio portrait shows Bamlett with a model of his first machine beside him.

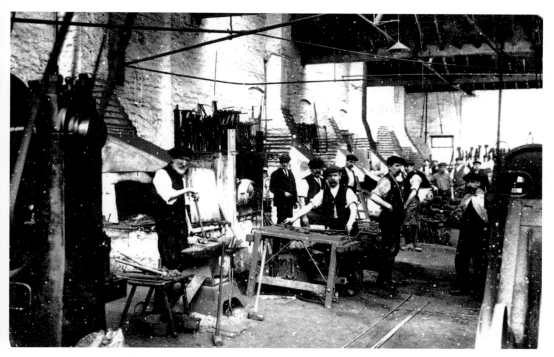

An interior view of Bamlett's factory before the First World War. It shows men in the forge; the chimneys leading up from the line of furnaces are seen clearly in the 1912 print on page 37.

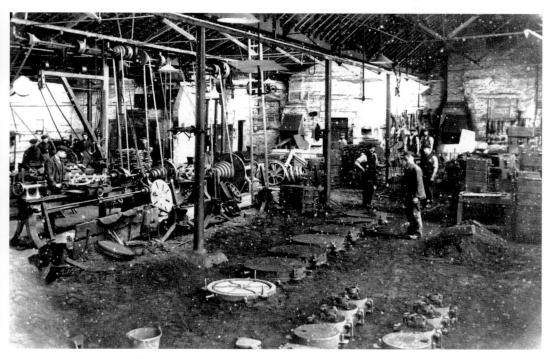

The foundry at Bamlett's showing rows of mould-boxes ready for casting.

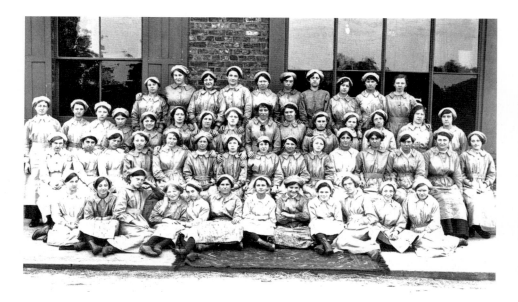

Women war workers at Bamlett's, 1914–18. While continuing to produce agricultural machinery during the First World War, the factory also undertook a number of government light engineering contracts, manufacturing large quantities of the screw-posts used for securing barbed-wire entanglements beyond the trenches. The firm recruited a large number of women workers to replace the men who had gone to the front. There are fifty-two in this group.

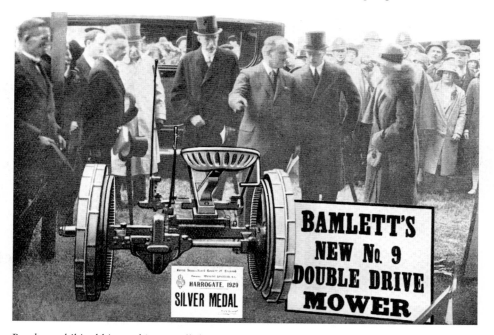

Bamlett exhibited his machines at all the major agricultural shows and many of the international trade fairs, winning a number of prestigious awards. This publicity card of 1929 shows the Duke and Duchess of York (the future George VI and Queen Elizabeth) at the Great Yorkshire Show.

Bamlett's stand at the Great Yorkshire Show in Festival of Britain year – 1951.

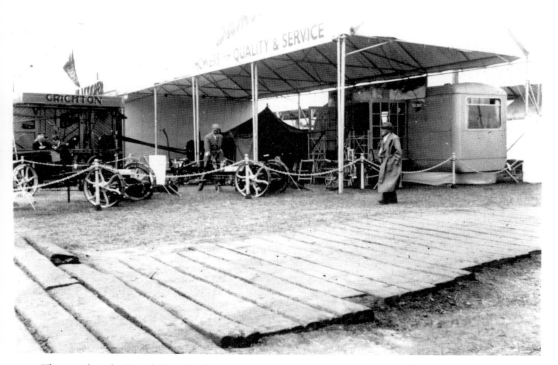

The stand at the Royal Show in the same year.

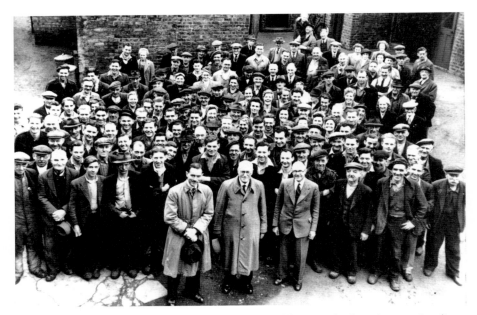

Bamlett's workforce in coronation year, 1953. The central figure at the front is managing director Mr Lomas. On his right is Mr Ward and next to him in the front row of workmen is Owen Palliser, thought to have been the last surviving employee to have worked for Adam Bamlett.

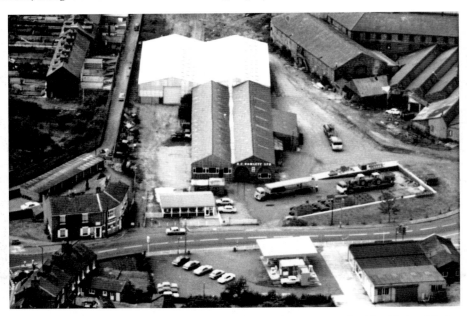

Bamlett's works seen from the air in 1985, shortly before the firm went into final liquidation. The latter days were unhappy ones; the market for Bamlett's traditional products had dried up, manufacturing at the Thirsk works had ceased and the firm was selling on machines brought in from abroad. The abandoned nineteenth-century workshops are on the right. The new sheds stand behind buildings of the old rail yard, while the former coal depot has been converted into a loading bay. Not long afterwards the whole site was cleared to make way for a supermarket, and is now the Tesco complex.

3

Around the Villages

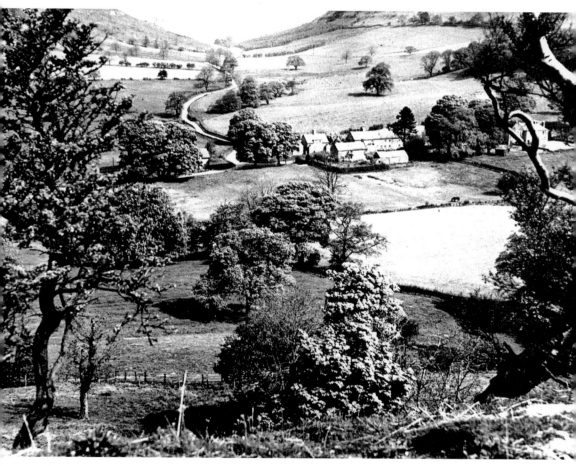

Kirby Knowle viewed from the hillside in 1954. The cluster of dwellings stands on the road which runs along the slope of the Hambleton Hills north towards Cowesby and Kepwick, south to Boltby and Felixkirk. Snaking down the valley westwards, the road goes to Upsall. This is one of many fine prospects that can be had of the string of hillside villages that lies above the Vale of Mowbray.

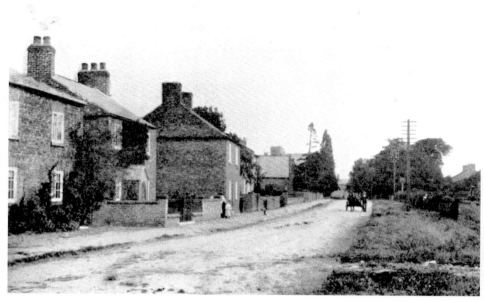

Carlton Miniott in a view by J. T. Fox of Thirsk, *c.* 1910. The original village lies a mile or so to the west of Thirsk, but a second settlement grew up from the 1850s around Thirsk Junction railway station and workshops on the North-Eastern main line. The view is eastwards towards Thirsk, with the Methodist chapel on the left and the inn sign of the Dog & Gun on the right behind the horse and cart. (*Ray Ballard*)

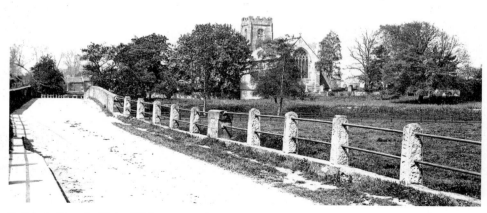

St John's Church, Kirby Wiske, across the water meadows of the river that gives the village its distinguishing name, *c.* 1900. The church was heavily restored in 1873 but retains a number of fine Norman features. There was a Saxon foundation here before the Conquest, attested by fragments of a cross and a hogback grave-cover found in the gardens of the former rectory. The village was the birthplace of Roger Ascham, tutor to the future Elizabeth I. (*Ray Ballard*)

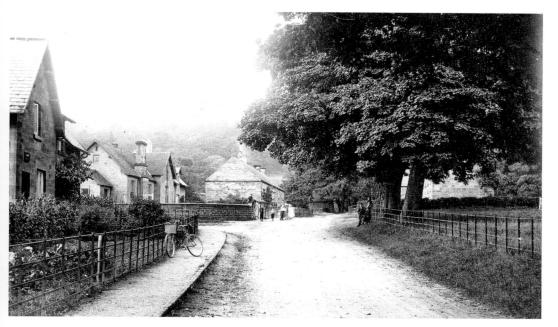

Kirby Knowle as seen by Thirsk photographer Clarke, *c.* 1910. The building with the prominent chimney-stack beyond the wall was the village school, built in 1862 by Charles H. Elsley of Newbuilding. The school closed in the 1960s but now serves as the village hall.

Standing above the street on the mound that was the motte of an early castle, Clarke took this view of Felixkirk at about the same time as his view of Kirby Knowle. The tower of the church, dedicated uniquely to St Felix, can be seen behind the trees. In the foreground is the doorway of the Carpenters Arms, now much enlarged, the adjoining orchard giving way to car parking. On the right is the neat little village school opened in 1835, now the village hall.

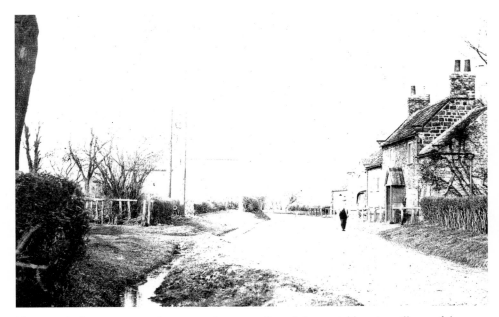

Thornton-le-Street seen on a Stevens card, *c.* 1910. One of three neighbouring villages of the same name, this Thornton was distinguished by its position on an old Roman road to Catterick. It is now a pleasant cul-de-sac off the A168 from Thirsk to Northallerton. The building on the right was formerly the Spotted Dog public house. (*Ray Ballard*)

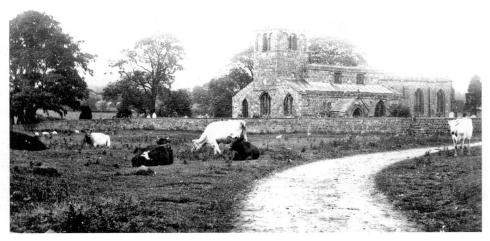

Leake church, *c.* 1904. Other than St Mary's and the manor house, which stands alongside, nothing remains of the ancient village of Leake save the name. The parish, however, was extensive and included seven townships in all, of which the two most important were Borrowby and Knayton, separated today by the busy dual carriageway of the A19. (*Ray Ballard*)

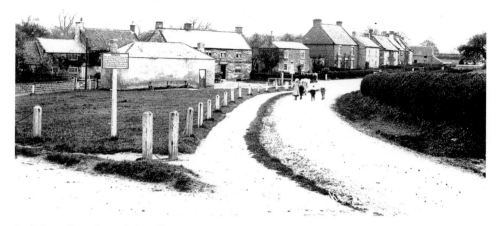

An Edwardian view of the village green at Knayton. The notice reads: 'Any person or persons damaging the Posts and Chains round the Village Green in the Township of KNAYTON will be prosecuted. By order of the Thirsk Rural District Council'. The three children in the roadway are accompanying a cow and her calf. (*Ray Ballard*)

Upsall village street, early twentieth century. The medieval manor of Upsall was owned by the great Yorkshire Scrope family who built a castle on the hillside overlooking the Vale of Mowbray. In 1768 the estate was bought by royal physician Dr John Turton and remains in the ownership of his heirs to the present day. The castle was rebuilt in 1875 in the Gothic style, as was much of the estate village. The Victorian building, however, was destroyed by fire in 1918; the present house dates from 1924.

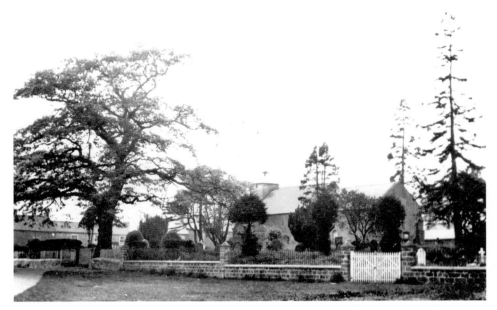

St Wilfred's Church, South Kilvington, 1900. The old road from Thirsk to Yarm runs through the village and there is a niche in the wall facing the road where a statue once stood to bless passing travellers. The Revd William Towler Kingsley, cousin to the writer Charles Kingsley, was rector here for over fifty years. A friend and correspondent of Turner and Ruskin, he was himself a skilled craftsman. The carved stalls in the chancel of this little church are his work.

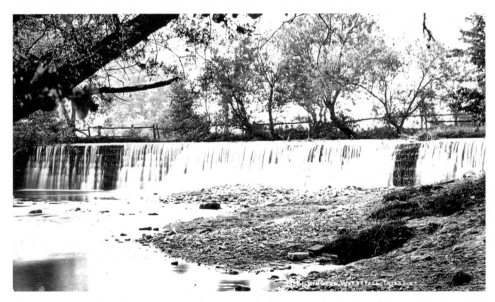

The weir at South Kilvington. One of a string of villages on the banks of the Cod Beck which flows down from the Hambleton Hills through Thirsk and on to join the Swale at Topcliffe, South Kilvington had its own mill. Worked at one time by Rymer's of Thirsk, the plant stood abandoned for some years when local milling ceased, but has been restored to working condition by an enthusiastic owner. (*Ray Ballard*)

Oldstead, 1900s. The name of this little cluster of cottages derives from the twelfth-century settlement there of the band of Savignac monks who went on to build Byland Abbey. To commemorate the coronation of Queen Victoria in 1837, John Wormald of Oldstead Hall erected a tower or observatory on the hillside overlooking the village. This view is towards the Black Swan Inn on the road leading to Coxwold. (*Ray Ballard*)

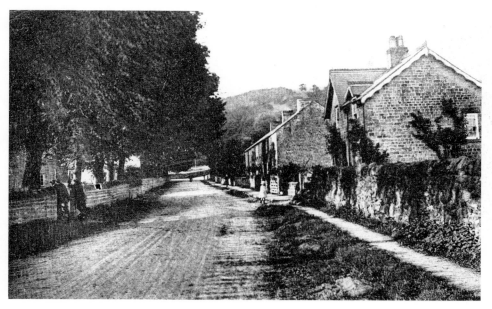

Wass, early 1920s. About 500 yards to the north of Byland Abbey, this village lies at the foot of the escarpment of the Hambleton Hills where the steep incline of Wass Bank takes the road lip to the moors. The view here is eastwards to the centre of the village; the road turns left towards Byland and Coxwold, with the Wombwell Arms behind the trees on the corner. (*Ray Ballard*)

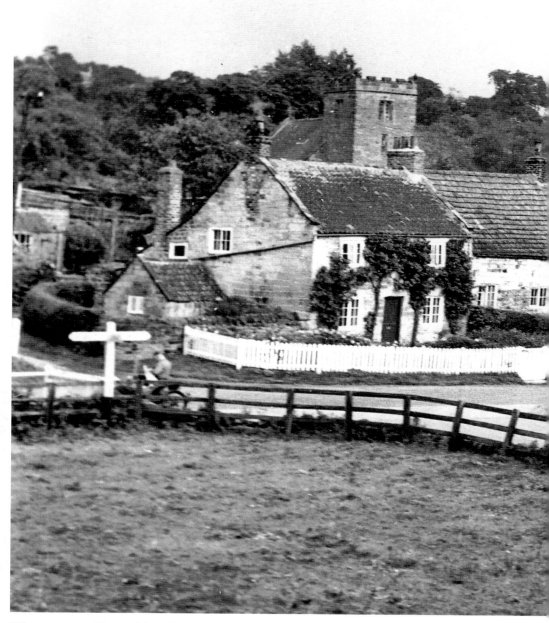

Kilburn, *c.* 1930. Home of the celebrated 'Mouseman' furniture-maker Robert Thompson, Low Kilburn lies tucked beneath the great White Horse cut into the hillside above, while High Kilburn stands on a higher level. The photograph catches much of the picturesque character of this stone-built village.

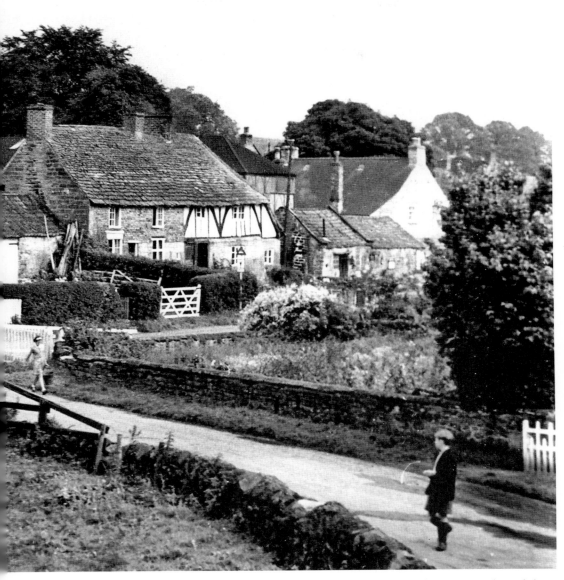

Thompson's house with its half-timbered upper storey stands in the row of cottages, with workshops alongside. (*John Butler*)

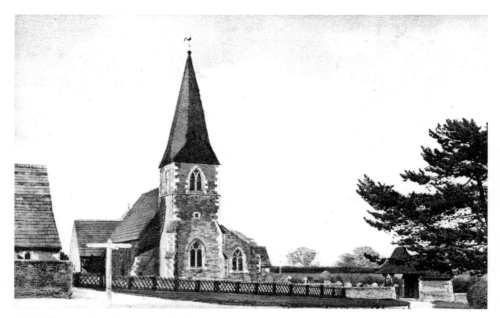

St Cuthbert's Church, Sessay, is highly rated by Pevsner in his book on the North Riding. It dates from 1848 and was built for Viscount Downe by architect William Butterfield as part of the improvements made to the Sessay estate. The village school stands alongside and was designed as part of the same project.

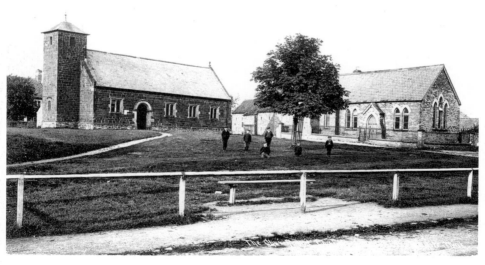

Church and chapel at Carlton Husthwaite from a Clarke photograph, c. 1900. The church dates from the 1670s and was built as a chapel-of-ease to the parish church at Husthwaite. It has a largely intact seventeenth-century interior. The Wesleyan Methodist chapel dates from 1869. A Village Institute and Reading Room was built next to the chapel in 1902. Both are now converted to private dwellings. The horse chestnut tree now dominates the green where it was planted by the Peckitts of Carlton Hall in about 1890. (*Ray Ballard*)

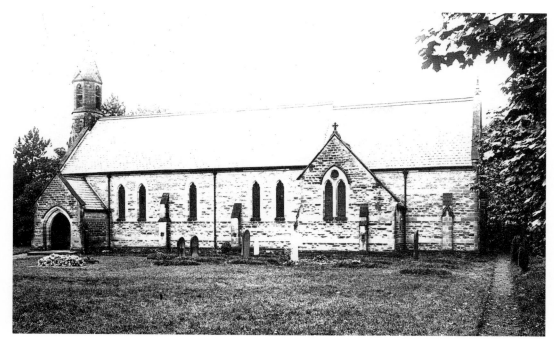

The church of St John the Evangelist, Dalton, *c.* 1900. This is another of Butterfield's designs for the Downe estates, dating from 1868. It has an unassuming exterior but its interior is lit by a remarkable series of windows designed by members of the Pre-Raphaelite Brotherhood: William Morris, Edward Burne-Jones and Ford Madox Brown. First rector of the new church was prolific author and hymn-writer Sabine Baring-Gould, best known for 'Onward, Christian Soldiers'.

Dalton village, looking towards the church, with the bell tower showing above the trees. The village school on the left of the road was built for Viscount Downe in 1873 to hold seventy pupils. It closed in 1966.

The east side of Front Street, Sowerby, 1970. The main street of Sowerby is characterised by a variety of houses standing side by side: cottages, villas and minor mansions, forming a fine social mix. Front Street has generous greens on either side, lined today by mature lime trees. planted in 1887 to celebrate Queen Victoria's Golden Jubilee.

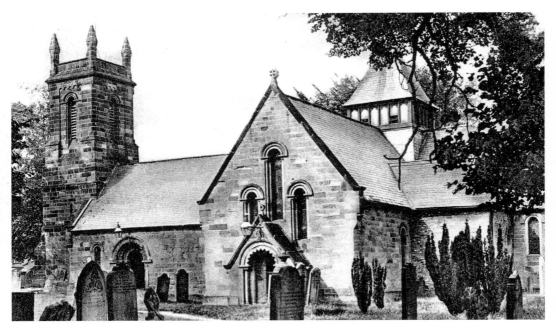

St Oswald's Church, Sowerby. Rebuilt in 1842 by E. B. Lamb, who did much work for the Pranklands of Thirkleby, St Oswald's retains a fine Norman doorway. The unusual roof lantern is a later addition, but admits light into the central area, regularly used for musical performances.

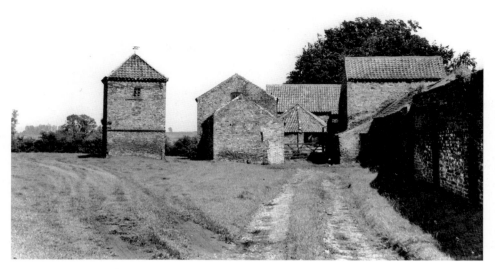

Manor Farm, Sowerby, 1970. The brick walls and pantiled roofs of the eighteenth-century farmyard here form a very picturesque group with the hexagonal horse-mill at the centre. Standing apart is a rare seventeenth-century dovecote, a structure that was once the privilege only of the squire or the parson. This one is now a listed building.

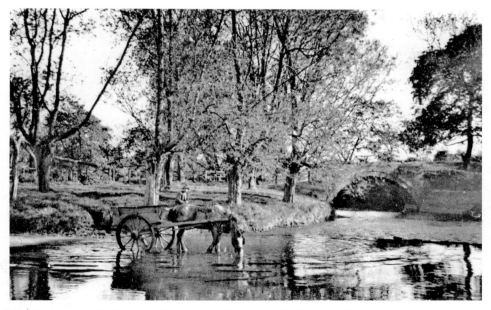

The ford at the World's End, Sowerby, in the 1920s. Until the modern road bridge was built. the only dry-shod crossing of the Cod Beck at the south end of the village was provided by an ancient packhorse bridge. Carts, wagons and other vehicles used the ford. The isolated public house which stood here was known to all as the World's End.

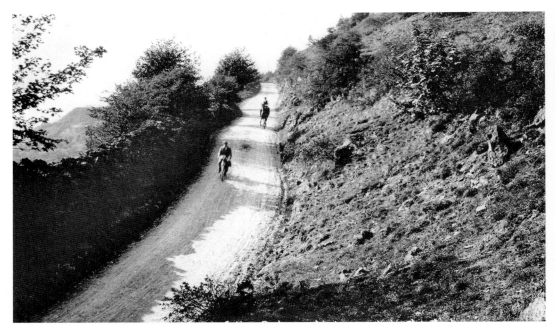

This postcard view of the perilous incline of Sutton Bank is dated October 1908. The long and precipitous one-in-four slope with its two sharp hairpin bends has for over a century tested both traction and braking power of motor vehicles, whether climbing or descending. In the years before the First World War it was a favourite venue for motorcycle trials. (*Ray Ballard*)

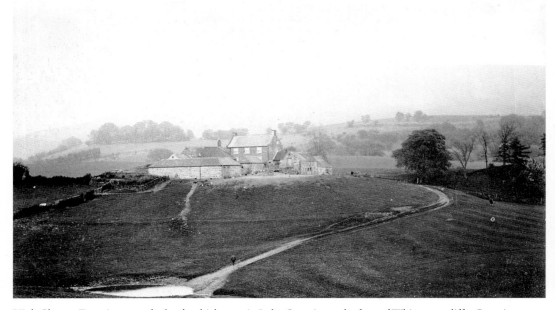

High Cleaves Farm is set on the bank which pens in Lake Gormire at the foot of Whitestonecliffe. Gormire itself is a geological puzzle, having neither inlet nor outlet, and is apparently fed by springs rising at the foot of the sandstone cliffs which mark the edge of the North Yorkshire Moors above. (*Ray Ballard*)

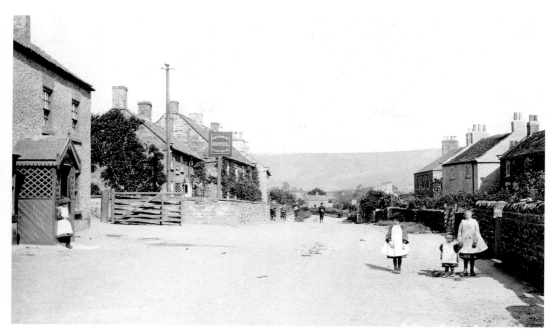

Sutton-under-Whitestonecliffe seen in a Clarke postcard, dated 1911. The line of the Hambleton Hills forms the background to this view of the village street, with the board of the Whitestonecliffe Hotel to the left promising 'Good Stabling'.

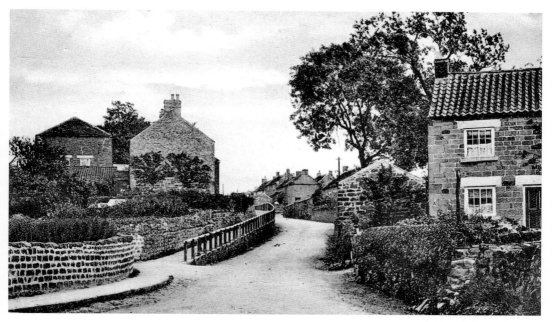

The entry to Sutton village, with the raised footpath serving the stone-built cottages on the left.

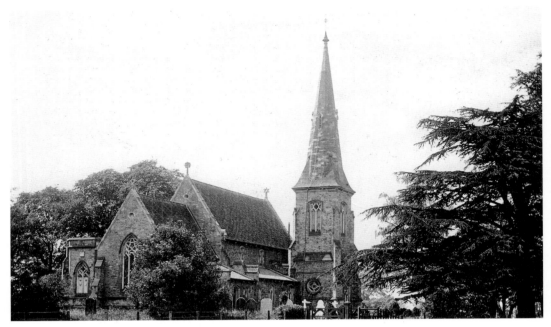

All Saints' Church, Thirkleby, *c.* 1900. This church was built in 1851 by Lady Frankland-Russell as a memorial to her late husband Sir Thomas. Her chosen designer was E. B. Lamb, regarded as a 'rogue' architect among his contemporaries; his creation is cheerfully described by Pevsner as 'a riot of forms, perverse and mischievous'. (*Ray Ballard*)

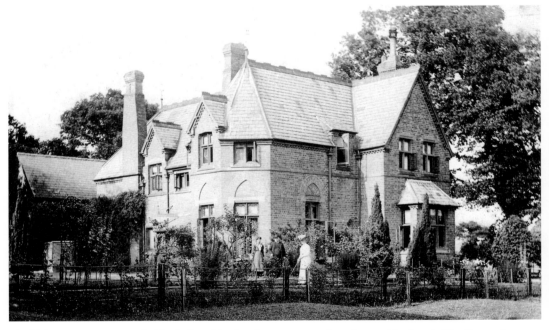

Thirkleby vicarage was probably designed by Lamb as a companion-piece to his church. The figures in the garden seem to be the Revd Thomas Hill Smith, vicar, with his wife and daughter. (*Ray Ballard*)

The Traveller's Trough, Thirkleby, *c.* 1910.
This water trough was erected by Sir Ralph
Payne-Gallwey of Thirkleby Park in the yard
of the former Griffin Inn, now a farmhouse,
on the main York road. The inscription reads:
'Weary traveller, bless Sir Ralph who set for
thee this welcome trough'. The figure posed
for the photographer is not a police constable
as appears at first sight: the round hat is not
a helmet and there are no badges on the coat.
He is probably a coachman. The trough has
recently been moved from its original position
and, sadly, no longer offers water.

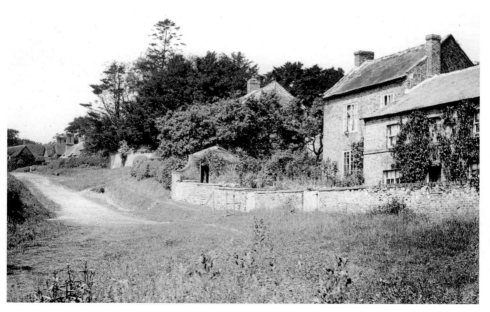

Cottages in Great Thirkleby, *c.* 1900. Great Thirkleby, on the Frankland estate, lies to the west of
the beck that divides it from the eastern township of Little Thirkleby, which formed part of the
Downe estate. The track on the left leads to a footbridge over the beck: neither landowner was
prepared to allow the two parts to be linked by a road fit for vehicles.

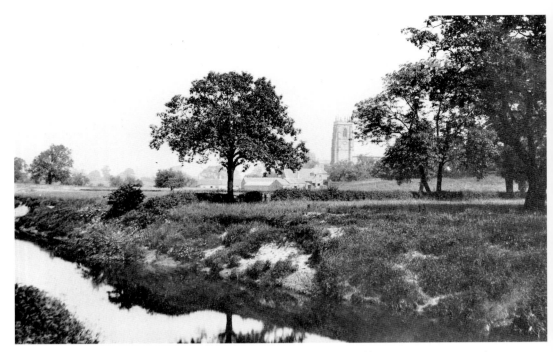

Topcliffe from the banks of the Swale, *c.* 1900. In medieval times Topcliffe was an important settlement and was one of the power bases of the great Percy family, Earls of Northumberland. The impressive earthworks known as Maiden Bower, visible still where the Cod Beck and Swale meet, are the remains of their stronghold. There was a market here and annually in July there was a great horse fair attended by dealers and travelling folk from all over the country. Topley Fair, as it was known, survived until 1969. The tower of St Columba's Church can be seen rising above the cottages on Long Street.

Long Street, Topcliffe, looking towards the bridge over the Swale. The cottage at the foot of the hill was the toll house for the bridge. The cottages and archway are no longer there.

This view shows the road leading north towards Northallerton. Prospect House is in the distance and the group of children are standing where a track turns off towards the mill. Glebe House is on the right, concealing the entrance to the vicarage.

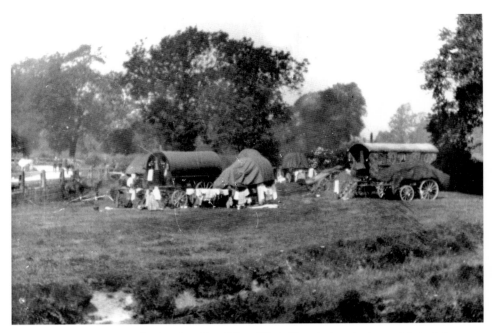

A gypsy encampment on the Asenby side of Topcliffe bridge during the horse fair in July 1907. Topcliffe's medical practitioner, Dr Carter Mitchell, made a point every year of visiting each caravan in full professional garb of frock coat and top hat to ask after the health of the occupants and bid them welcome.

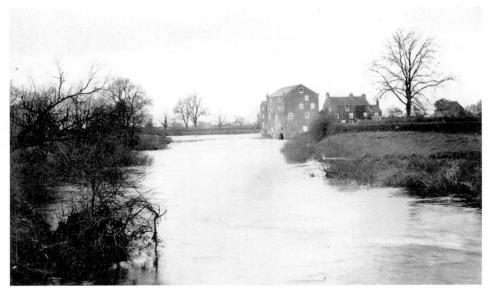

Topcliffe Mill with the Swale in flood, early twentieth century. There was a mill at Topcliffe recorded in the Domesday Book, but the building seen here dates from 1769. It was run for most of the nineteenth century by the Dresser family and the Moons, then into the twentieth century by the Listers. The last miller, Maurice Lister, retired in 1961, when the mill ceased work. It has now been converted into apartments.

4
Seats of the Gentry

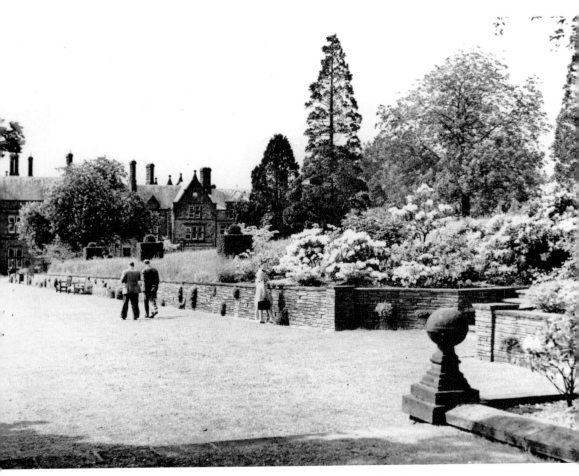

The gardens of Kepwick Hall, 1954. The hall is a late Victorian building dating from 1873, when the estate was bought by Edward Warner. He laid out the grounds to great effect, incorporating notable water features fed from reservoirs built into the hillside.

The rich farmland of the Vale of Mowbray, the glorious landscape of the Hambleton Hills, the opportunities for hunting and horseracing and for indulging a taste for the life of a country gentleman led great landowners and wealthy industrialists alike to acquire estates in the area around Thirsk and build themselves fine mansions. The life of the big house with its army of servants, stablehands and gardeners, its summer picnics and autumn shooting parties was at its height in the years before the First World War, a period that coincided with the peak of the fashion for collecting picture postcards. After the war the decline set in; many of the estates could no longer pay their way, and agriculture, trade and industry all felt the effects of recession. Many of the estates were split up and sold off and the great houses, no longer capable of being maintained, were demolished or turned into schools and nursing homes. Thirsk photographer Joseph R. Clarke made a round of these mansions in the 1900s, leaving us a valuable record of how they were then. We are fortunate in those houses that have survived.

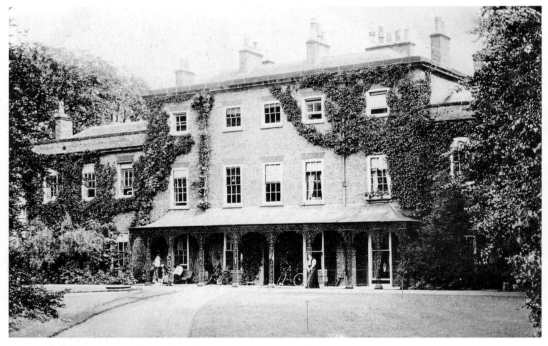

The garden front of Thirsk Hall, *c.* 1902. Thirsk Hall stands next to St Mary's Church at the top of Kirkgate. This was probably the site of the original manor house in the days when Thirsk formed part of the estates of the Stanley family, the Earls of Derby. In 1723 the manor of Thirsk was bought by Ralph Bell of Sowerby who built himself a modest mansion here. In 1770 John Carr of York was commissioned to enlarge the adding a second storey and the two wings existing today. The house has some very good interiors.

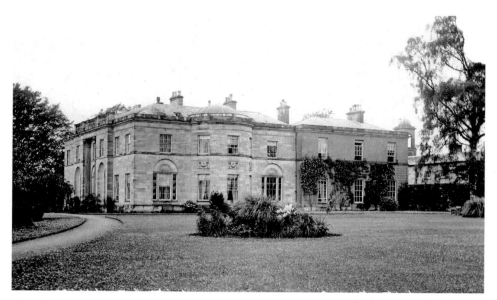

Thirkleby Park, *c.* 1900. In February 1786 farmer William Metcalfe of Sessay records in his diary: 'Went to John Toes then to Thirkleby, saw the new Hall.' This fine mansion had just been completed for Sir Thomas Frankland to designs by James Wyatt. The Payne-Gallwey family became owners of the hall in the nineteenth century, but following the death in action of the direct heir in 1916 the estate passed to a distant relative who sold it off. The mansion was stripped out and finally demolished in 1927.

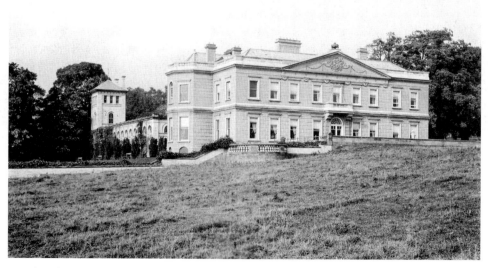

Wood End at Thornton-le-Street from a card postmarked 1904. The property was first owned by the Talbot family, who sold it to Samuel Crompton in 1793. He carried out much work on the house, which was further altered in the last part of the nineteenth century when it became the property by marriage of the 3rd Earl Cathcart. Following the death of his son in 1911, the house was let out and finally bought in the 1920s by a consortium of speculators, known locally as the Forty Thieves, who dismantled Wood End, leaving only the stable block and gatehouses.

Kilvington Hall, *c.* 1910. The manor of North Kilvington was held by the Meynells, an old Roman Catholic family who suffered much for their faith. The old manor house was converted to a farm when the family moved away to Yarm, but until the 1860s retained a chapel for Catholic worship. The new hall was built for family use in 1835. (*Ray Ballard*)

Upsall Castle in the early years of the twentieth century. This rambling Gothic edifice was built for Captain Edmund Turton in the 1870s to replace the ruins of the Scropes' medieval castle. The building was gutted by fire in 1918; although the alarm was raised in Thirsk, the local fire brigade were unable to catch their horse grazing on the Flatts at Sowerby and arrived too late to do more than damp down the smouldering remains. A much reduced house was erected on the site in 1924. (*Ray Ballard*)

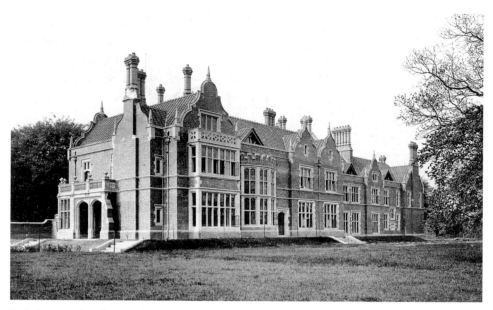

Built in a neo-Jacobean style with extensive gardens, Breckenbrough Hall dates from the second half of the nineteenth century. It was the seat of Captain T. Cowper Hincks, JP, who was an enthusiastic grower of orchids. The building is now home to an independent school.

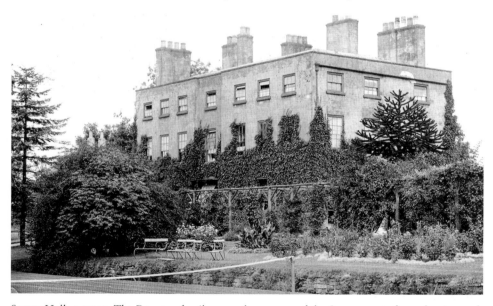

Sessay Hall, *c.* 1902. The Dawnay family were the owners of the Sessay estate from the sixteenth century. Ennobled in the Irish peerage as Viscounts Downe, they had a modest mansion built here in the Italian style, but after the death of her husband in 1856 Lady Downe took up residence a few miles away at Baldersby Park, formerly occupied by George Hudson, the Railway King. Sessay Hall then became the home of successive rectors. The gardens were clearly well kept and the tennis court in the foreground hints at the leisurely life enjoyed by the family of a well-to-do country parson.

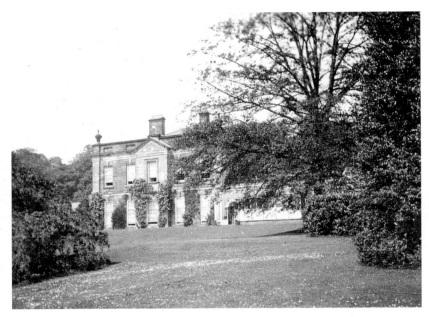

Mount St John stands on the site of a commandery erected above the village of Felixkirk by the Knights of St John of Jerusalem. The order was disbanded at the time of the Dissolution in 1534, their estates being confiscated and leased to secular tenants. In 1720 this elegant house was built for the Revd William Elsley whose family had large property holdings in the North Riding. In the 1860s the estate was bought by twin brothers, wealthy industrialists John and Edmund Walker. John remodelled and extended the house which remained in the ownership of his family for the next hundred years.

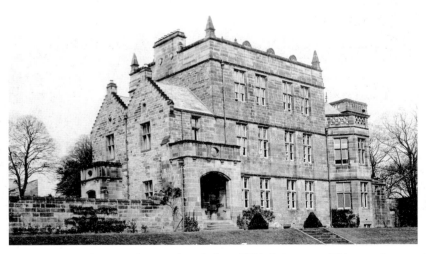

Newbuilding, near Kirby Knowle, seen by Clarke of Thirsk in 1904. This mansion stands on the vaults of a late thirteenth-century castle which became the property of the Constable family. Confiscated under Cromwell, the castle was bought in 1653 by James Danby who rebuilt part of the old castle and added the south front, calling it Newbuilding. The mansion eventually passed to the Elsleys of Mount St John who were still in occupation in the early years of the twentieth century.

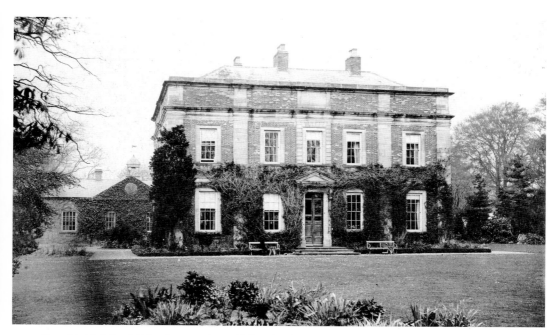

Brawith Hall lies hidden by trees just off the Thirsk to Northallerton road beyond Thornton-le-Street. One of the less well-known houses of the district, it was built by the Consett family towards the end of the eighteenth century. (*Ray Ballard*)

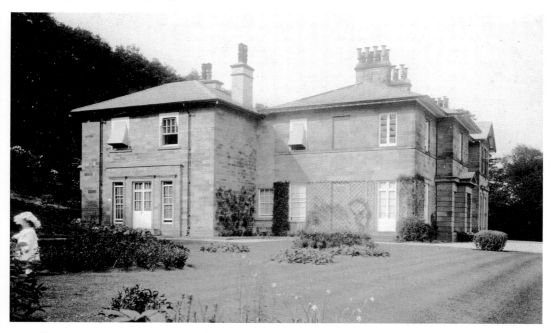

Ravensthorpe Manor, *c.* 1900. The name of the little girl standing among the roses is not known. but she adds a characteristic note to Clarke's photograph taken in high summer. Until the 1850s this was Westow Hall. Its Victorian owner built a new house and appropriated the more imposing title of Ravensthorpe from an ancient site a couple of miles away above the village of Thirlby.

The upper part of the gardens of the Hall at Sutton-under-Whitestonecliffe in the years before the First World War. Sutton Hall had been the home of an eccentric elderly lady, but was bought and refurbished by a Mr James Edwards who planted extensive gardens that were a local showplace.

The waterfall in the Sutton Hall gardens. Mr Edwards developed the beck that flowed through the gardens to form an extensive water feature. Note the little hexagonal summer-house which can also be seen above on the left. (*Ray Ballard*)

5

War Years

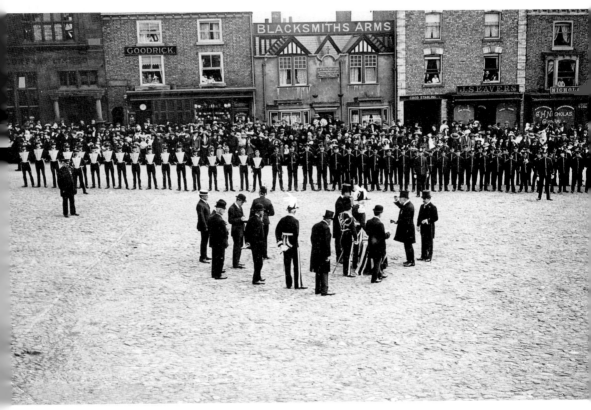

Thirsk Military Sunday, 1914. This was an annual parade of uniformed organisations in the years before the outbreak of the First World War. Lord Helmsley, the figure on the right of the group of dignitaries, is about to proceed with the presentation of badges to members of the National Reserve. The elaborate uniforms of the Yorkshire Hussars on the left of the parade were soon to be exchanged for the khaki of the trenches. (*Ray Ballard*)

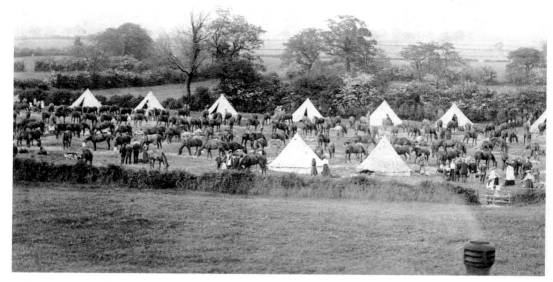

10th and 18th Hussars in camp at Thirsk, 5 June 1906. The cavalry came regularly to Thirsk in the 1900s. Local breeders supplied horses to the mounted regiments and specialised in providing matched teams for the artillery. Annual camps held in the Vale of Mowbray gave men and horses respectively a breath of Yorkshire air and a bite of Yorkshire grass as a welcome change from the routine of city barracks. The camp is open to the public who are strolling freely among the bell tents and horse lines.

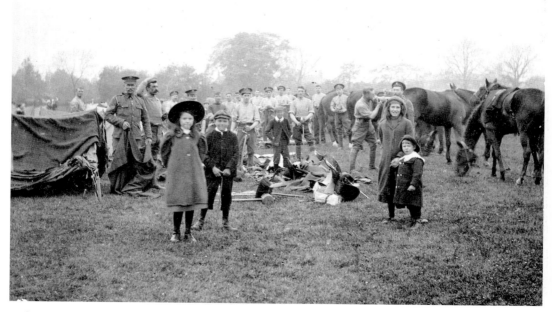

18th Hussars at camp the following May. It seems to have been a chilly morning. There appear to be no adults accompanying these children enjoying the bustle of the cavalry lines. (*Ray Ballard*)

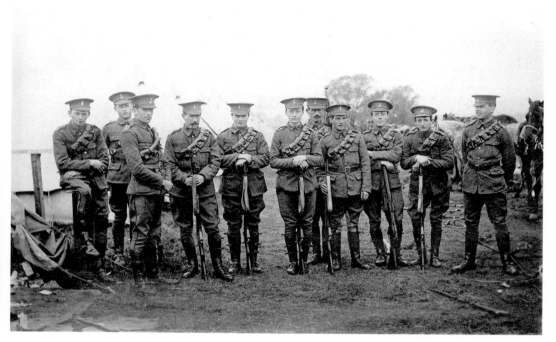

Volunteers of the Yorkshire Hussars in camp at Bishopthorpe, May 1913. A note on the back of this photograph identifies the group as the Thirsk Troop, 'E' Squadron. Jim Ryder signs the card and says he is having 'a ripping time'.

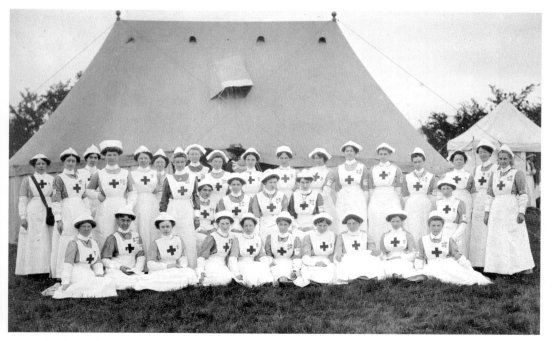

Thirsk members of the nursing service formed as the Voluntary Aid Detachment at a rally and competition in 1914. As with the men in the previous picture, their training was soon to be tested in earnest.

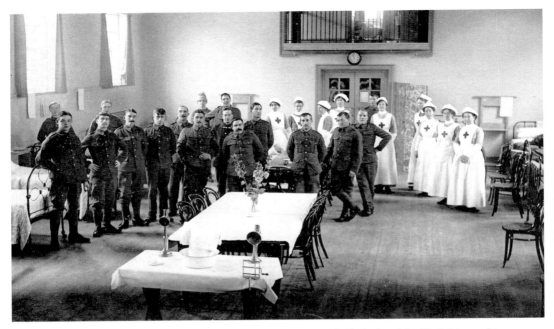

Thirsk Town Hall as a military hospital in 1915. The new town hall, designed by Yorkshire architect Walter Brierley, was opened in 1913 and within a year was pressed into service as a military hospital, taking convalescent soldiers from Leeds. The ladies of the Thirsk Voluntary Aid Detachment are seen here in the main hall which served as the ward.

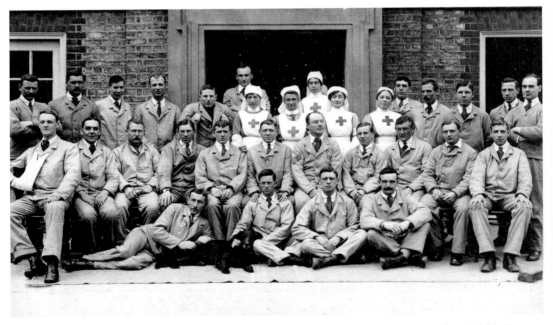

Convalescent Tommies at the town hall in March 1916. The patients are now wearing 'hospital blue', the uniform with white shirt and red tie that distinguished the wounded soldier and explained his absence from the front.

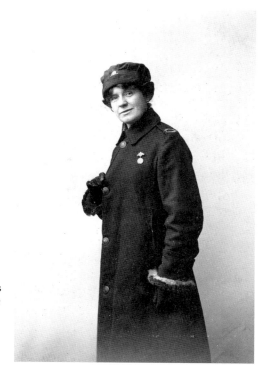

Sister Bel Horner of Thirsk Red Cross Hospital, March 1918. Bel Whitteron had come to Thirsk as a schoolteacher. She married soldier Harry Horner in 1915 and continued teaching in school during the day and working in the hospital at night. It was the war effort of women like Bel Horner that finally helped win them the vote.

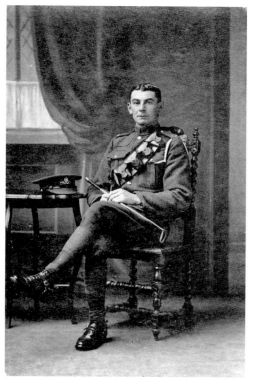

Royal Artilleryman Thomas Wilson Rutherford (1883–1946). Thomas was the eldest son of a well-known Thirsk farmer and butcher. A note on the back of this photograph claims him proudly as one of the two most outstanding horsemen in the district.

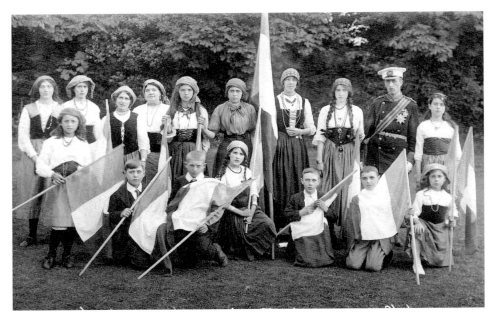

Thirsk War Play, 1915. In 1907 Thirsk mounted an ambitious historical play in the grounds of the hall. This was followed in 1912 by an equally large-scale Rose Show and the same enthusiasm seems to have inspired the fund-raising production of a war play in 1915. This took the form of a series of tableaux celebrating the Allied Nations. This group represents Italy, an ally in the First World War. The young lady first left in the back row is Madge Rutherford, youngest sister of Thomas seen on the previous page; she lived to be ninety-three.

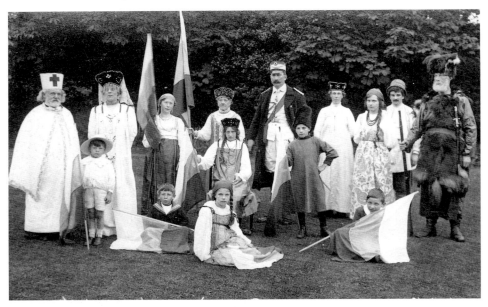

This second tableau from the 1915 war play represents Russia. A lot of work has gone to costume the players. The giant figure of a Cossack on the right was played by taxidermist 'Taffy' Lee, who seems to be wrapped in a complete skin rug!

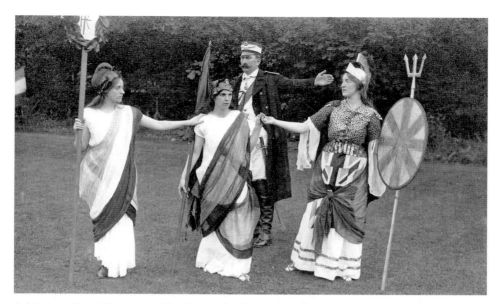

Belgium and her Allies, 1915. The figure of gallant little Belgium stands supported by Marianne, spirit of the French Republic, and Britannia, with Tsar Nicholas of Russia in the background. The 1915 Thirsk audience had no idea of the terrible fate that awaited him.

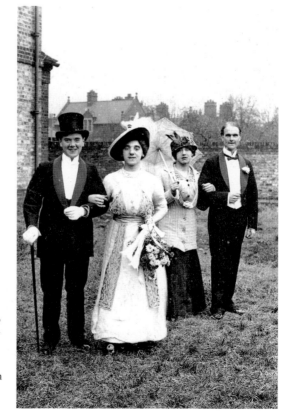

A concert party in aid of the Red Cross Hospital, November 1916. Various entertainments were organised on behalf of the town hall hospital and its patients. The identity of these performers is not known, but the group included cinema manager Walter Power who put on regular film shows at the Picture House next door for the benefit of the troops. The roofs of Thirsk's own Lambert Hospital can be seen in the background.

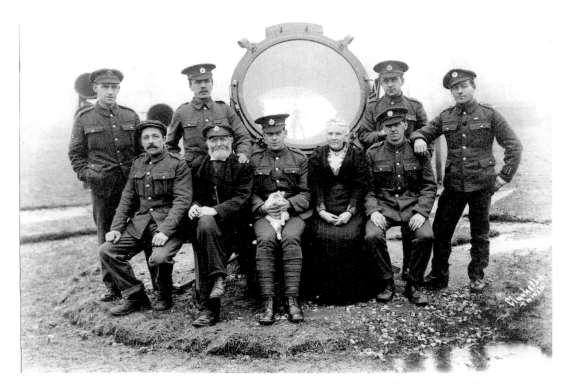

Searchlight unit at Brick Yard Farm, 1916. It is not always remembered that a sustained bombing campaign against targets in England was carried out by Zeppelin airships. Towns on the east coast were vulnerable and it was not until 1916 that effective anti-aircraft defences were established. The men of the unit at Brick Yard Farm, Sandhutton, are sitting with farmer James Chapman and his Welsh wife Catherine. Catherine invited the men to eat with the family in the farmhouse; when an inspecting officer objected she replied that she would do as she pleased in her own house, and the troops continued to enjoy her excellent cooking. Note that James and the man next to him have exchanged caps. (*C. Marchal*)

Opposite: Air-raid wardens and other civil defence personnel march through St James' Green in 1942 or 1943. Parades of uniformed organisations were a feature of wartime fundraising campaigns urging investment in National Savings. Warship, Salute the Soldier, Wings for Victory Weeks were all occasions for exhibitions, displays and parades. In November 1941 Thirsk adopted *Arctic Ranger*, an armed trawler, and presented the vessel with a commemorative plaque carved in oak by 'Mouseman' Thompson.

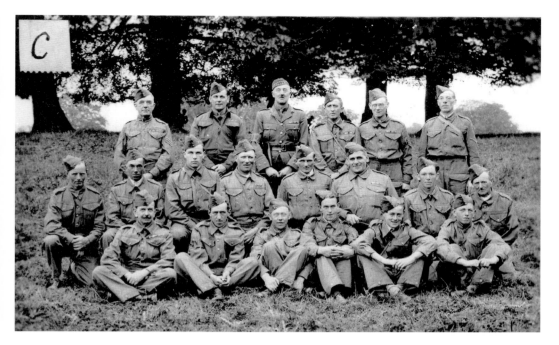

Local Defence Volunteers, May or June 1940. Formed hastily after a broadcast appeal by Anthony Eden on 17 May 1940, the Local Defence Volunteers were often equipped with no more than armbands and shotguns. In July, as weapons began to be issued and proper uniforms provided, the name was changed to the Home Guard. This local unit has not been identified, but the denim uniforms, LDV armbands and lack of badges show that it must have been in the early days of the force.

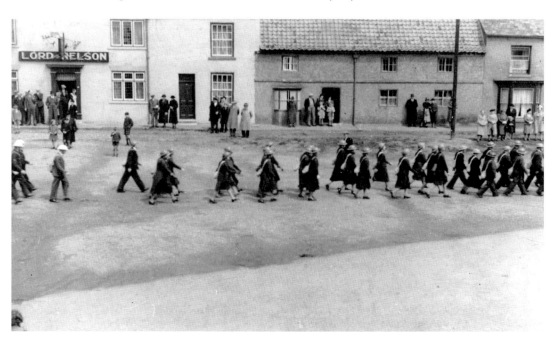

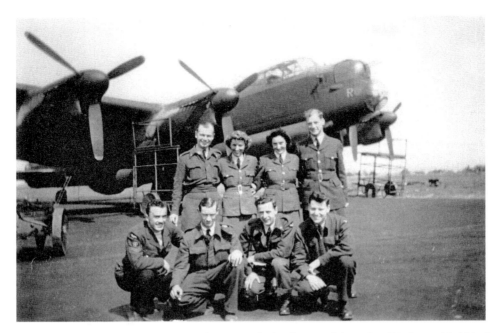

Orderly Room staff at Skipton-on-Swale, 1945. The level acres of the Vale of York provided ideal bases for the bomber squadrons that raided targets in Germany on an almost nightly schedule. Between 1942 and 1946 Skipton-on-Swale was home to two units of the Royal Canadian Airforce, 424 (Tiger) and 433 (Porcupine) Squadrons. Canadian airmen were familiar figures in and around Thirsk throughout this time.

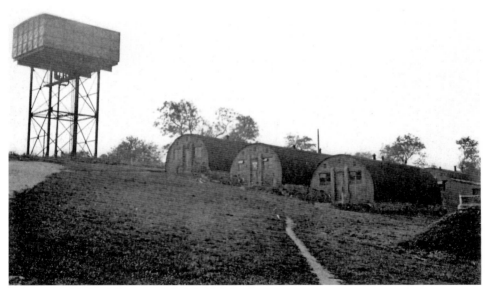

Living quarters at Skipton. August 1944. The RCAF flew Halifax heavy bombers from this base, later converting to Lancasters. The huts were machine-gunned by enemy aircraft during the last week of the war in Europe, fortunately without casualties.

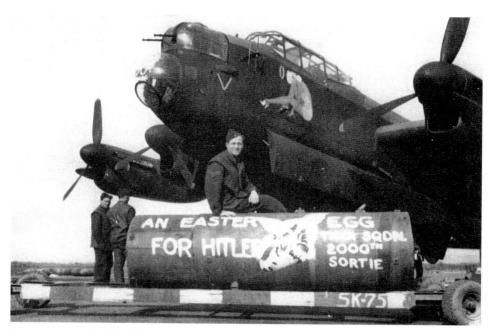

Bombing up with a blockbuster at Skipton, April 1944. The Canadian squadrons suffered heavy losses in the course of operations over Germany and many planes returning crippled by enemy fire crashed in the neighbourhood of Thirsk. There is a memorial at Skipton on the site of one of these tragic events.

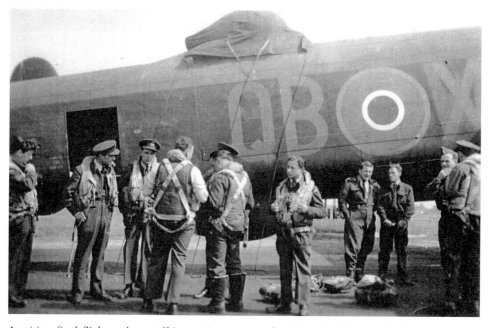

Awaiting final flight orders at Skipton. June 1945, after the end of the war in Europe. A crew from 424 Squadron is all set for a flight to Germany, but the tarpaulin over the upper gun turret indicates that no opposition will be encountered.

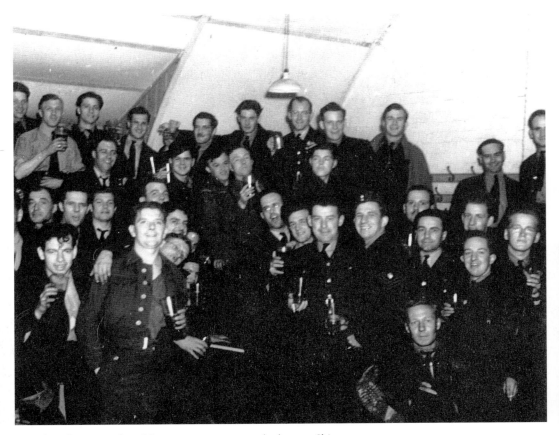

Canadian fliers in a cheerful mess room scene on the base at Skipton.

6

Families & Children

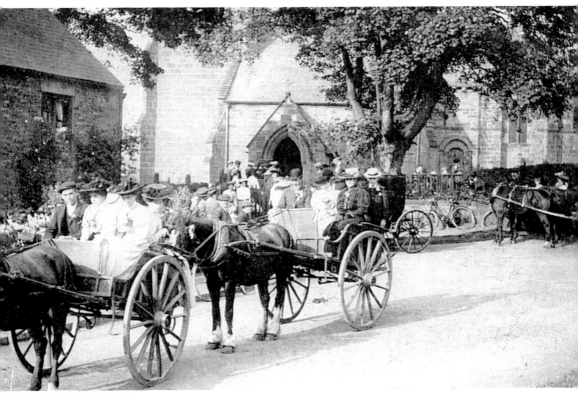

A village wedding, *c.* 1900. The names of bride and groom are not known, but the church in the background is St Felix at Felixkirk.

A magnificent wedding group, August 1898. The marriage was that of Edgar Brookwell Peat and Lucy Annie Robinson. The Peat family owned a printing and publishing business in Thirsk; Edgar's father David, the bearded gentleman standing behind the bridegroom, also acted as registrar of births and deaths for the district. Lucy was the daughter of a well-to-do farmer.

Edgar Peat is seen here in costume for a part in the Thirsk Historical Play of 1907. Photographed with their father are eldest son Donald and daughter Muriel Annie.

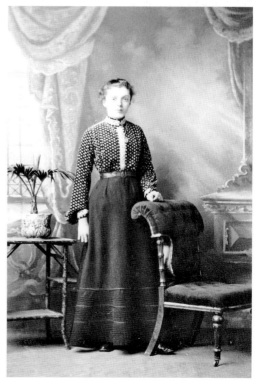

Miss Edith Barley, 1903. A charming example of Clarke's studio portraits, featuring an upholstered chair and a bamboo table that appear in many of his indoor photographs. Edith Barley was a farmer's daughter from Abel Grange just off the Newsham road. She was twenty-one in 1903; this picture may have been taken to mark the occasion.

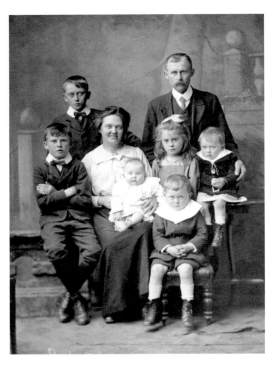

Thomas and Ellen Buck with their children, 1921. Thomas Buck worked at Breckenbrough Hall for Sir Francis Samuelson. Standing at the back is Thomas jnr and seated next to Ellen is George. Ellen is holding baby Elizabeth, while to her right are daughter Margaret and son Alfred; son John is seated at the front.

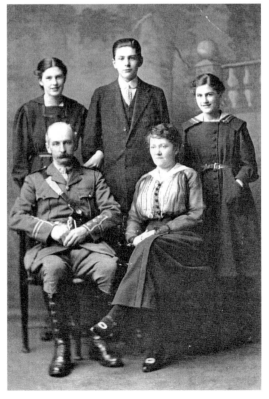

Arthur and Florence Pearson with their children Doris, Carlton and Minnie, during the First World War. The Pearson family lived at The Ingrams, a large house by the bridge in Ingramgate. Arthur's father had owned a seed-merchant's business in the Market Place. Both Arthur and his son Carlton were active members of Thirsk cricket and hockey teams.

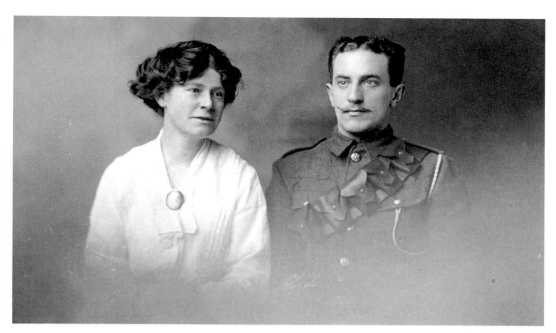

Bel Whitteron and Harry Horner, 25 January 1915. This double portrait was probably intended to mark the couple's engagement; they married in April of the same year. Harry was serving with the 4th Royal Irish Dragoon Guards.

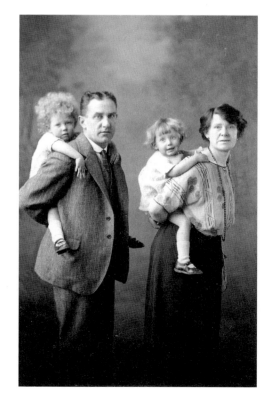

Bel and Harry Horner with their two daughters in 1923. This unusual family group shows Harry with elder daughter Cynthia, while Bel carries Yvonne. The late Yvonne Horner had an outstanding career as an international hockey player; she was coach to the British team at the 1976 Olympics in Montreal.

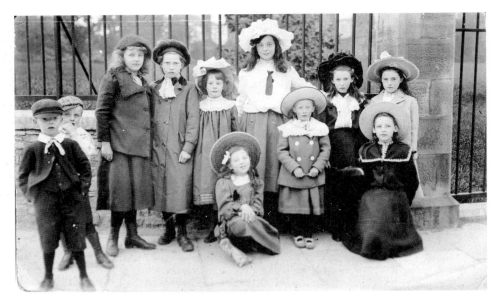

A parade of hats in the early years of the twentieth century. This is a delightful fashion plate of Edwardian children's clothing. The youngsters are clearly dressed for an occasion in styles reminiscent of Edith Nesbit's *Railway Children*. The two boys on the left seem mistrustful of the photographer, but the girls are happier to show off a variety of outfits. and above all their hats, essential items of outdoor dress for young and old alike.

Children on Pudding Pie Hill, late 1890s. This picture also displays the great range of juvenile attire of the period and offers a further collection of headgear. Pudding Pie Hill is a sixth-century burial mound that is now overshadowed by the embankment of the A168. It was a favourite scrambling spot for tobogganing in winter and egg-rolling at Easter. It was said that if a person ran nine times round the hill, climbed to the top and stuck a knife in the ground, fairy voices could be heard within.

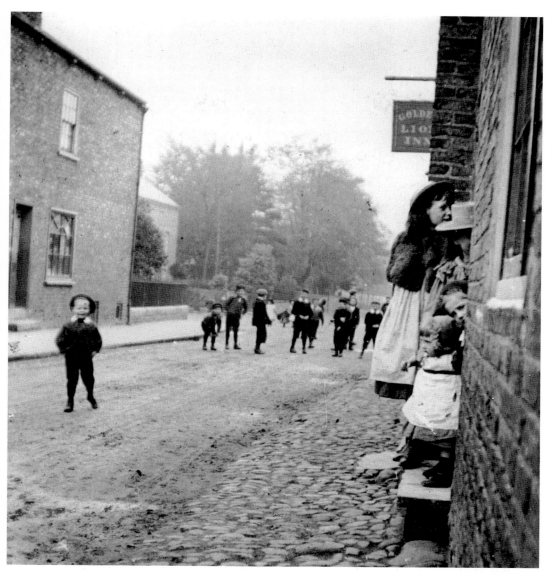

Children at the upper end of Front Street, Sowerby at about the same time as the view of Pudding Pie Hill. It looks as though the lads in the distance are on their way home from school, while the girls in the foreground have charge of a toddler. The sign board of the Golden Lion Inn can just be seen.

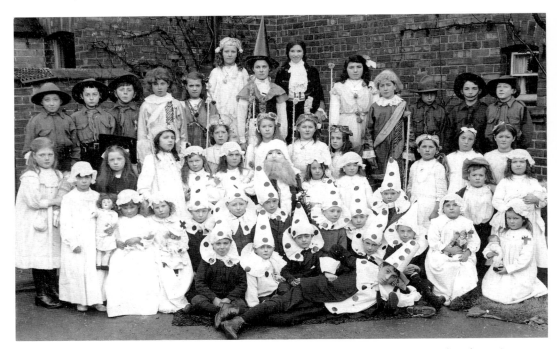

The cast of a children's entertainment, *c.* 1912 No details are given about the occasion, but the variety of costume suggests that these children were performing several different pieces or tableaux. The inclusion of six boy scouts puts it after 1909 when the first scout troop was formed in Thirsk. Pierrots were a very popular form of concert-party entertainment at the seaside in Edwardian times.

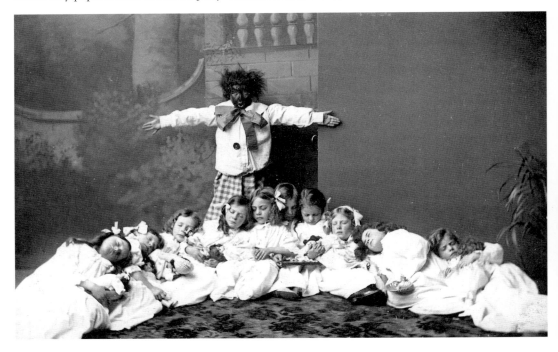

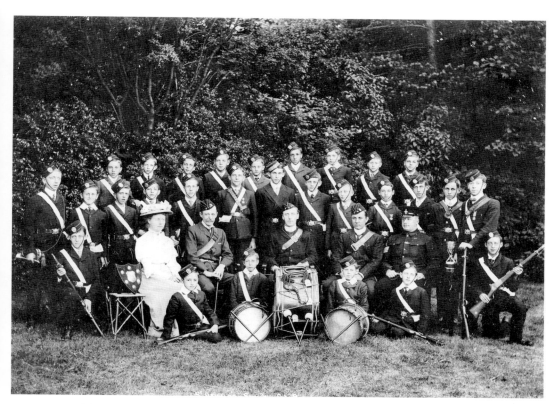

St Oswald's Church Lads' Brigade, *c.* 1912. Modelled on the Boys' Brigade, the first uniformed youth organisation, established in 1883, the Church Lads' Brigade sought to encourage discipline and good citizenship among boys within the Anglican community. The CLB was founded in 1891. The uniform, similar to that of the Boys' Brigade and based on contemporary army styles, consisted of a pill-box hat, a leather waist belt and a pipe-clayed cross belt. Most units had a bugle band which accompanied marches and parades. Much time was spent on drill; the boys were trained in marksmanship and took part in regular rifle-shooting competitions. Two trophies are displayed.

Opposite: Children performing at the Salem Chapel Bazaar, March 1914. This tableau would be unacceptable today, but it enacted a popular children's song whose closing lines ran: 'Hide, hide, hide your little faces 'neath the bedclothes white. When you're safely tucked up in your bed, say "Mr Golliwog, goodnight!"' Florence Upton had invented the Golliwogg (*sic*) as a character in a children's book in 1895, and the doll enjoyed popularity until banished from the nursery as an undesirable caricature of black people.

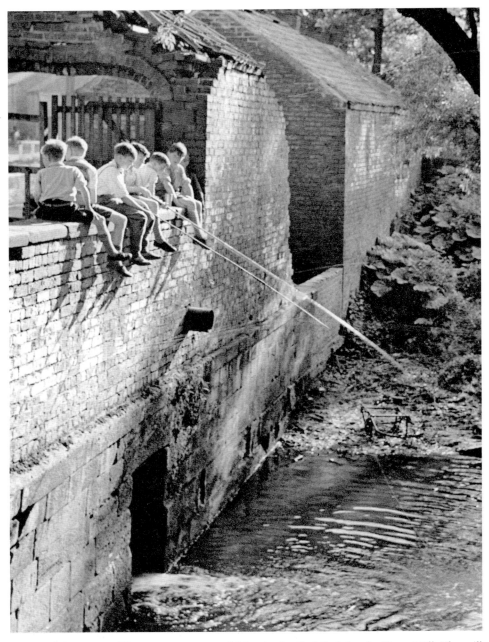

Young anglers, 1954. These youngsters are fishing in the Cod Beck by the Town Mill. The mill was demolished in the early 1970s and a small garden was laid out within the foundations. There is still good fishing to be had in the river.

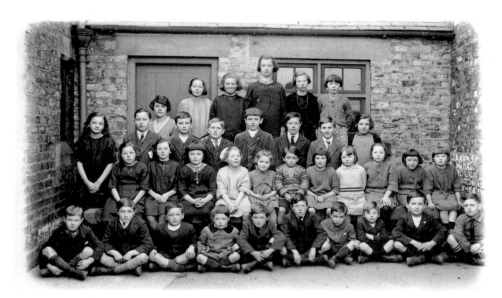

The children of Birdforth School, 1926. Seated fifth from left in the front row is John Butler and sixth from left, Stephen Galloway. Standing first on the left in the second row is Amy Gaines, second from the right is Frank Butler. The Board School at Birdforth was built in 1877 to serve the hamlet of Birdforth and the neighbouring townships of Thormanby and Carlton Husthwaite. It could accommodate fifty pupils and was staffed by a headmaster, an assistant teacher and one or two pupil-teachers. The building is now a restaurant. (*John Butler*)

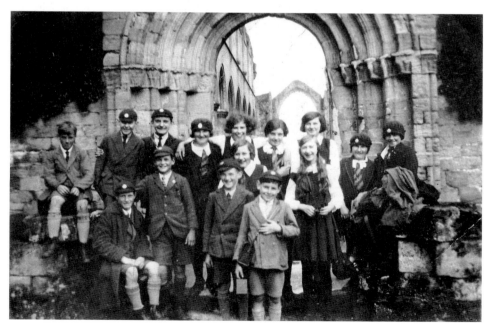

Pupils from Easingwold School at Fountains Abbey, 1931. With gymslips and berets for the girls and short trousers and caps for the boys, the uniform is typical of school fashion in the 1930s. (*John Butler*)

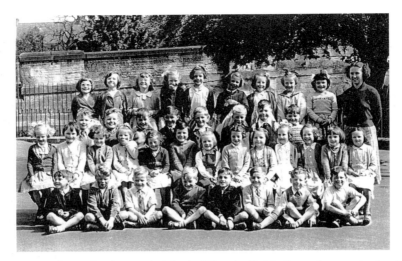

Thirsk County Infant School, 1956/7. The building in Finkle Street is now the local library. The teacher, Mrs Jean Cave, went on to be headmistress of Sowerby County Primary School. Back row, left to right: Anne-Marie Jackson, Joyce Brayshaw (?), Lynne Burton, Carol Johnson, Heather Brown, Cynthia Easby, Cynthia Ashby, June Ward, Julie Jackson. Third row: John Carr, Alan Kirby, Leslie Allenby, Michael Fillery, David Baume, Leslie Wright, William Tait, Richard McEndry. Second row: Sheila Huntley, Cynthia Thornton, Margaret Hunton, Pamela Ginnety, Patricia Parsons, Linda Rowe, -?-, Norma Barnett (?), Sheila Lofthouse, Rosalind Hood, ? Adams, Vivien Stevens (?), Zena Reynard. Front row: -?-, Michael Morrissey, Peter Grainger, David Fall, Michael Addison, Peter Sunley, Philip Kilvington, Tony Konieczny.

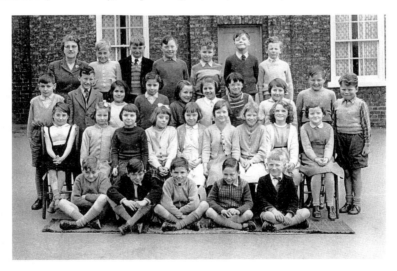

Thirsk Undenominational School, Long Street, 1958/9. The teacher was Mrs Peltor, wife of the vicar of Kilburn; they later moved to Shropshire. Back row, left to right: David Fall, Alan Blunden, Clive Hayton, John Carr, William Tait, Philip Kilvington. Third row: Terry Hutchinson, Brian Watson, Jean Knevitt, Heather Brown, Rosalind Hood, Cynthia Easby, Elizabeth Stapleton, Cynthia Ashby, Derek Barr, Michael Morrissey. Second row: Margaret Taylor, Carol Griffiths, Vivien Stevens (?), Beryl Craig, Eileen Goudy, Joyce Brayshaw (?), Carol Johnson, Lynne Burton, Margaret Hunton. Front row: Peter Sunley, John Minican, -?-, Colin Lambert, Peter Grainger.

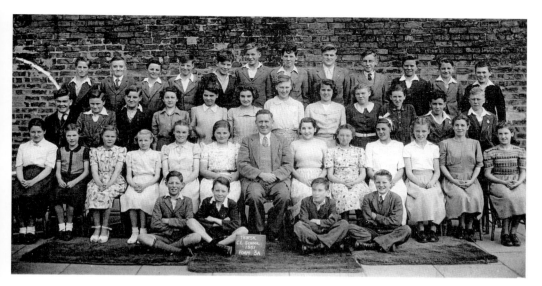

Thirsk Church of England School Class 3A, 1951. This school merged with the Undenominational School to form the Community Primary School in new buildings. Back row, left to right: George Player, George Umpleby, Tony Brown (?), Keith Swales, Michael Watson (?), Ray Simpson, Harry Foxton, Ken Wakefield, John Stubbs, Gerald Turner, Brian Ward, -?-. Third row: Geoff Bendelow, Mike Daniels, Gary Cooper, Doreen Dale, Shirley Dalloway, Elizabeth Smith, Dorothy (?) Adams, Diana Bumby (?), Dorothy Kirk, Dorothy Thompson, -?-, -?-. Second row: Pat Marshall, Dorothy Lea, Mavis Scott, Joyce Armstrong, Jean Carver, Betty Forster, Mr Stephenson, Beryl Hibbard, Tracey Thompson (?), Ann Bendelow, Hazel Smith (?), Ann Coltman, Sonia Cartwright. Front row front: John Hornigold, John Garthwaite, Roland Coates, Leslie Childs.

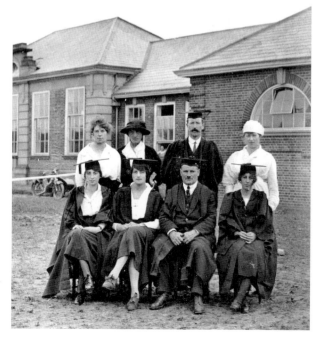

Thirsk Secondary School Staff, 1920. This first secondary school for the Thirsk district opened in 1920 in new buildings on Topcliffe Road. Thirsk School now occupies a large campus further down the road, while the buildings seen in the background here serve Sowerby CP School. Standing, left to right: Miss Stansfield, Mrs Peatfield (head's wife), Mr M. G. Clark, Miss J. Barker (domestic science). Seated: Miss D. Umpleby. Miss M. Gladstone, Mr Peatfield (headmaster), Miss H. Guy.

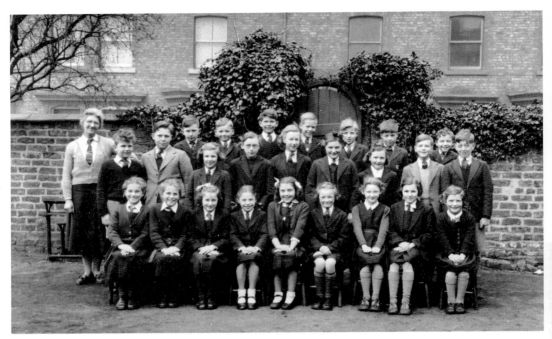

Ivydene School, Topcliffe Road in 1951. Ivydene was a small private school run first by two sisters, the Misses Joll. In the late 1930s it was taken over by Miss Harlow who was succeeded by Miss Eves, seen here with her pupils, among who stands a young Jimmy Wight, son of Thirsk vet Alf Wight whose stories written under the pen name of James Herriot brought him unexpected fame round the world. Back row, from left to right: David Humphries, Freddy New, Andrew Wyon, Michael Cawood, David Berry, Jimmy Wight, Christopher Wright. Middle row: David Wyon, Brian Hope, Mary Bateman, Pat Ward, Isobel Rymer, Betty Garbutt, Joan Atkinson, Harry Vowles, Ian Codling. Front row: Valerie Swanston, Rosalind Swanston, Jean Atkinson, June Metcalfe, Carol Starr, Janet Ramsay, Christine Wood, Patsy Weighell, Margaret Dawson.

7

Community Life

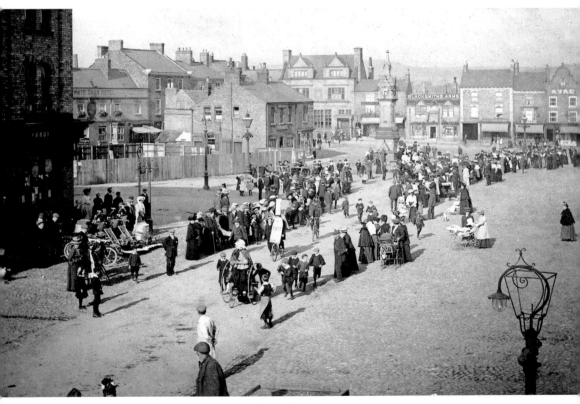

Thirsk United AFC Cycle Parade, 1908. Organised as a fundraising event, this was a competition for decorated cycles. The leading machine was already an antique when this event took place. Quite unintentionally, the photographer has also provided an interesting view of the Market Place where the old gas lamps stand side by side with the new electric standards, while in the background hoardings fence off the site cleared of old shops to make way for the new post office.

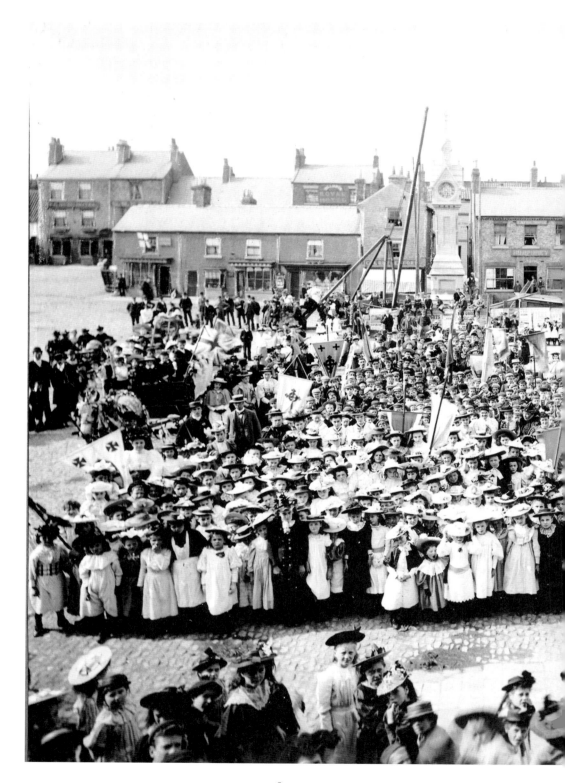

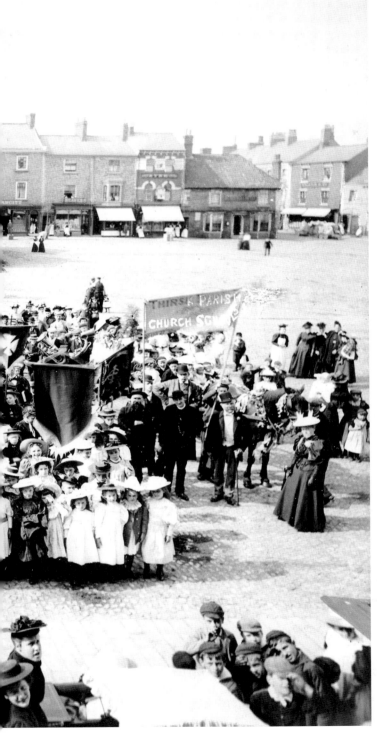

Thirsk Parish Schools Festival, 28 July 1896. Joseph Clarke recorded the scene outside the Golden Fleece, providing us with a remarkable panorama that holds a wealth of fascinating detail. Work has paused in the background where the new market clock is nearing completion. The parish magazine reports: 'Teachers and scholars of day and Sunday Schools formed in procession and marched through the town with banners waving in the sunshine. The Volunteer band led the way. When the Market Place was reached, a grand square was formed and two festival hymns were sung, the band playing the accompaniments.' Afterwards there were sports and a feast in the grounds of Thirsk Hall.

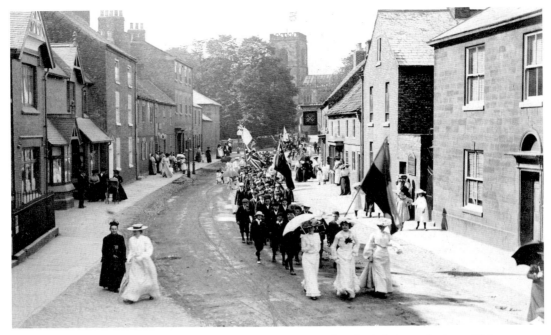

Parish Schools festival, 12 July 1904. Three ladies in summer white lead their pupils down Kirkgate past the Cross Keys, the Quaker Meeting House and the Brewery House on the right. The house with the railings has become famous as Alf Wight's James Herriot surgery. (*Ray Ballard*)

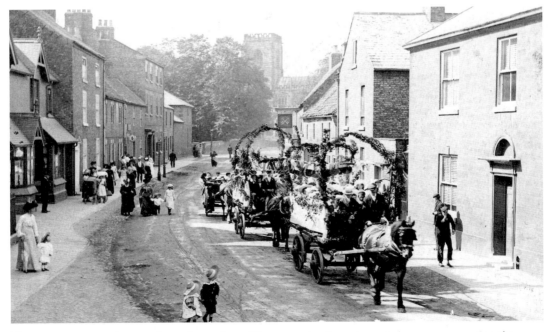

The same scene as above, a few minutes later. These are the three decorated waggons carrying the children of the infant schools, 'overflowing with happiness and glee'. (*Ray Ballard*)

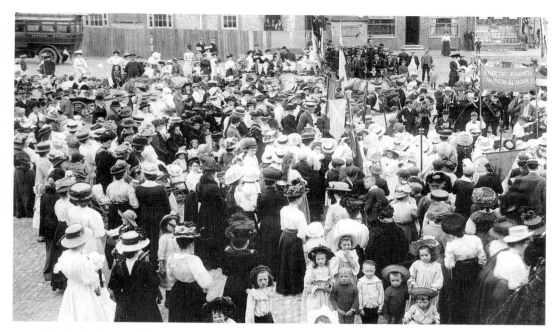

The Festival, 1909. Once again we are in the Market Place, this time among the crowd of mothers, most of whom are clearly specially dressed for the occasion. In the background the new post office is visible behind the fencing, and on the left stands one of the motor buses run by the North Eastern Railway to convey passengers from the town centre to the station.

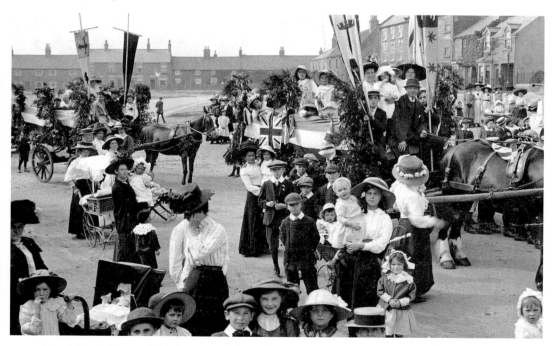

School Festival, 1912. This is a more informal scene. The procession is assembling on St James' Green and the horse-drawn floats are ready to set off.

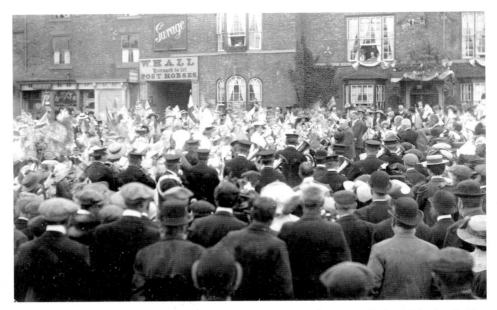

Coronation celebrations in Thirsk, 22 June 1911. The crowd is assembled outside the Golden Fleece to celebrate the coronation of George V. The band is grouped in the centre; to the left the forest of flags marks where the children are gathered. The 'Garage' sign above the coach entrance to the inn yard show that post-horse licensee William Hall has kept abreast of changing patterns of travel.

Coronation celebrations in Sowerby. Entertainment and refreshments were provided for all in Sowerby on Coronation Day. Two marquees were erected in the grounds of Manor Farm next to the church, still the traditional venue for village events today.

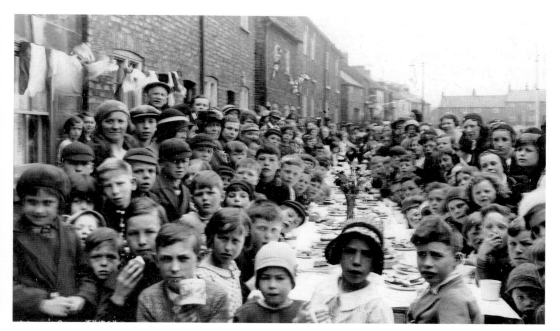

A street party on St James' Green, 1935 in celebration of the Silver Jubilee of George V and Queen Mary. Families living on St James' Green organised an open-air party for local children, each of whom received a commemorative mug like the one displayed by the boy on the left. There are still a number of residents who can recognise their younger selves in this group. (*Ray Ballard*)

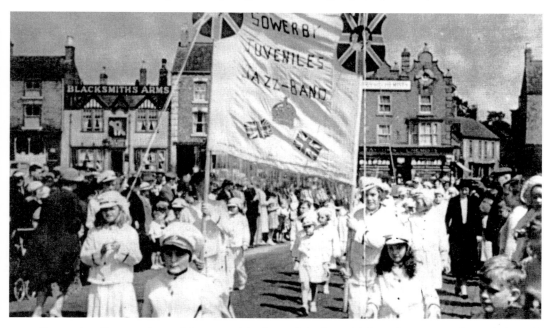

Coronation Day parade, 12 May 1937. Members of the Sowerby Juveniles Jazz-Band march through Thirsk Market Place as part of the parade to celebrate the coronation of George VI and Queen Elizabeth. Marcher Dorothy Ashall is holding the banner stay on the left. (*Dorothy Ashall*)

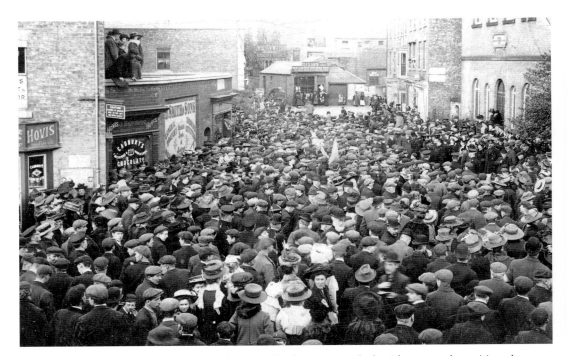

Declaration of the poll, 1910. The roadway in Castlegate is packed with a crowd awaiting the declaration of poll for the Thirsk and Malton constituency. The 1910 election had been keenly fought locally between the Conservative candidate Lord Helmsley and the Liberal J. J. Briggs. Victory went to the Conservatives, with Lord Helmsley securing a majority of 1,185.

Opposite: Thirsk head post office staff, 1959, first thing in the morning before the delivery staff set off on their rounds. The counter staff had to come in early. Back row, left to right: Charlie Dale, Harry Cook. Fourth row: George Hayden, Ernest (Tim) Simpson, Sid Butcher. Third row: George Claxton, Guy Sleights, Mike Close, Bert Hodgson, Reg Scott, Maurice Burtoft, Peter Stephenson, Sid Robinson. Second row: Donald Stamp, Ted Moyser, Edgar Wood, Percy Hunton, Lou Ainsley, Arthur Sunley, Jim Matthews, Arthur Snow, Bill Simpson, Fred Hibberd, Fred Dennis. Front row: Annie Blakey, Sheila Postgate, Ralph Hemingway, Reg Marshall (head postmaster), Joan Pyne, Eric Riley.

Special constables for the Thirsk district. A 1950s group with a proud display of medal ribbons and some recognisable faces. In the back row, George Cockeril and Ron Nicholas. In the fourth row: fourth from left – Joe Hewson, seventh from left – mill owner Jim Rymer. In the third row: seventh from left – furnisher Reg Holmes, ninth from left – TSB manager Mr Scruton, tenth from left – Mr. Nicholson, taxis. In the second row: fourth from left – Arthur Metcalfe, sixth from left – regular police inspector Savage, eighth from left – chemist Mr Gibbeson. Seated in the front row: first from left – Tom Richardson, fifth from left – sweetshop owner Mr. Rose.

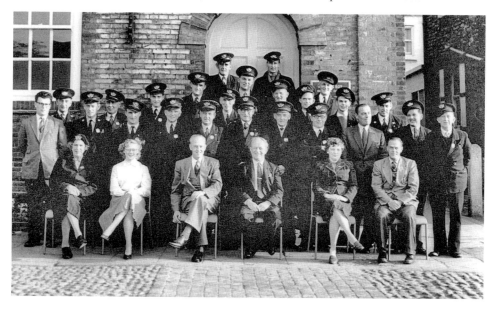

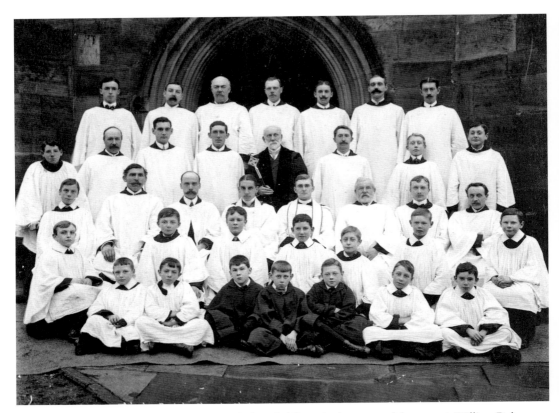

The choir of St Mary's Parish Church, 1911. The bearded figure in the centre of the group is William Dale Bateman, grocer, verger and parish clerk, a venerable and highly respected member of the community. His family name still appears in beaten copper on a shop-front in the Market Place and is preserved in Bateman's Yard. Seated third from the left in the third row is the organist and choirmaster, Arthur James Todd. Third from the right in the same row sits bearded Zacky Wright, stationer, bookseller and noted sportsman. The vicar in 1911 was the Revd Hubert Pearson H. Austen.

St Mary's choir in the early 1950s. Organist Arthur Todd appears again nearly forty years later; he did not retire until 1956. Back row, left to right: Dave Cooper (churchwarden), Harry Barnett, Percy Hunton, George Raper, Jack Stott, Bob Stephenson, Wilf Pattison, Major Peter Bell (churchwarden). Second row: -?-, Jimmy Swailes, A. Readman (?), Mike Hardwick, Jack Bradley. Front row: Jim Cornell, Brian Foster, D. Barron, Billy Kay, Arthur J. Todd (organist and choirmaster), the Revd Harry Broughton, Maurice Armstrong, -?-, Albert Armstrong, D. Bradley.

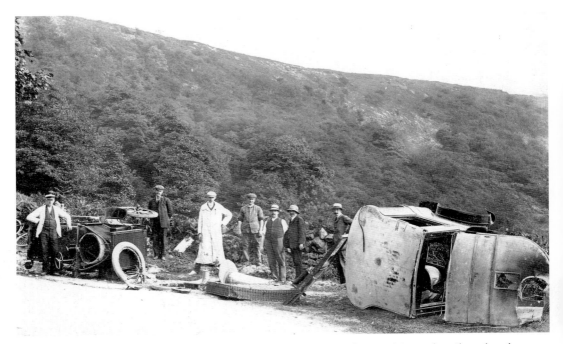

A road accident on Sutton Bank, 2 September 1906. Flood, fire, explosion, shipwreck, rail crash – the Edwardian lover of picture postcards was always ready to add a new disaster to the collection. This card shows the aftermath of one of the first road traffic accidents on the notorious Sutton Bank. The figure in the centre with the long car-coat may have been the unlucky driver. The registration plate of the vehicle reads CE 54 – a Cambridge number. This would not be the last case of a motorist unfamiliar with this perilous incline coming to grief!

8

Craftsmen & Countryfolk

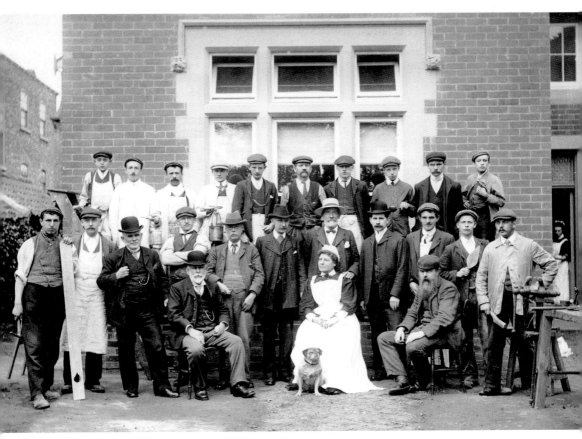

Extension to the Lambert Hospital, 1906. There is an echo of the Middle Ages in this Clarke photograph of the workmen at the Lambert Hospital in Thirsk sternly displaying representative tools of their craft. Plumber James B. Amos stands on the extreme right, a lead-beater in his hand and a blowlamp on the bench beside him. The Lambert Memorial Hospital was opened in 1890 and the west wing nearing completion in this picture was added in 1906. The matron at the time was Miss M. White, the honorary medical staff being Drs Buchanan, Ferguson and Longford.

Robert Thompson of Kilburn (1876–1955). This informal snap of 'Mousey' Thompson on the doorstep of his cottage in Kilburn was taken in about 1940. Furniture carved from oak and bearing his signature of a mouse is highly prized all over the world. To have worked for Thompson and to have been trained in the Kilburn workshops was valued highly. The business is thriving today in the hands of his great-grandsons. (*John Butler*)

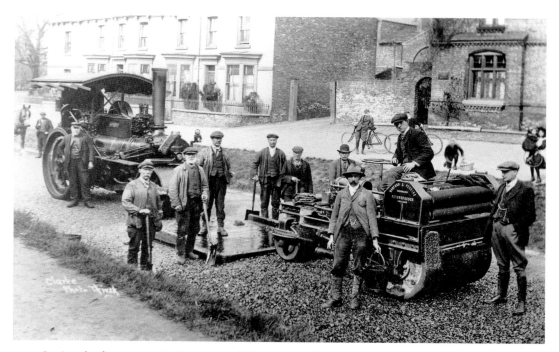

Laying the first tarmac in Ingramgate, Thirsk, 1910. This unusual photograph was taken practically on the doorstep of Joseph Clarke's studio in Ingramgate. The introduction of tarmacadamised road surfaces was of great importance in the years when motor transport was developing. The mechanical details of this picture are of interest; the steam-driven road-roller became a familiar sight as the resurfacing of streets proceeded.

Opposite: James Wright Smith at work, 1952. There is a tradition of fine craftsmanship in the villages along the edge of the Hambleton Hills. Jim Smith was a noted cabinetmaker; he is seen here finishing a typical piece in his workshop in Upsall.

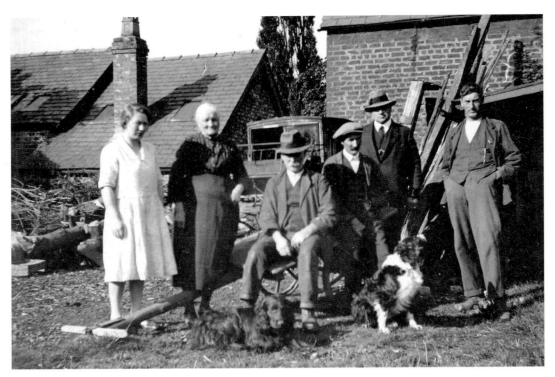

The Butler family at Sunnybank Farm, Carlton Husthwaite, early 1930s. Left to right: Mary Johnson, Margaret Butler, William Butler, John Butler, Harry Fielding (?), Frank Butler. (*John Butler*)

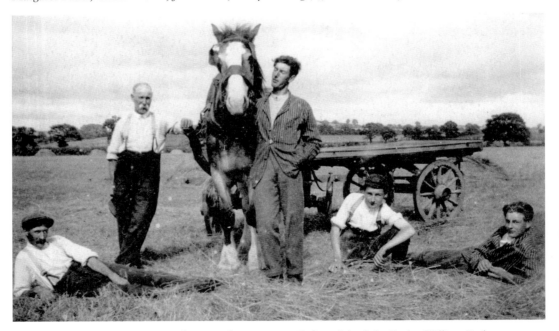

Haymaking in Common Lane, Carlton Husthwaite, 1917. Left to right: John Butler, William Butler snr, Frank Butler snr, George Butler, William Butler jnr. (*John Butler*)

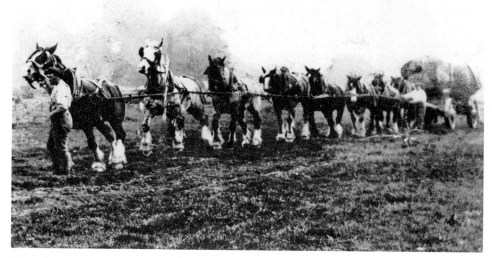

Heavy horse team, 1920s. In a scene that could have been painted by Lucy Kemp-Welsh, a team of eight heavy horses harnessed in single file draw a waggon carrying a very bulky load. This could be timber or possibly a consignment of stone from the quarries above Kepwick. The horses were supplied by the Edmondsons of Boltby.

George Edmondson, prizewinner at Otley show, August 1910. George Edmondson stands with the horse, which came first among seventeen in the Open Class for Cleanest Horse and Harness.

Above: Stack-yard scene, *c.* 1910. The location of this picture is not certain, but the scene is typical of a Vale of Mowbray farm in the days before mechanisation. The stacks of hay are roughly covered against the weather. The frames propped against the wall on the right were slotted into the front and rear of a waggon to support large loads of hay or corn.

Making butter, 1973. Dorothy Broadwith of Manor Farm, South Kilvington, is using a butter worker to squeeze the remaining buttermilk from the butter before making it up into pats.

9

Sport & Entertainment

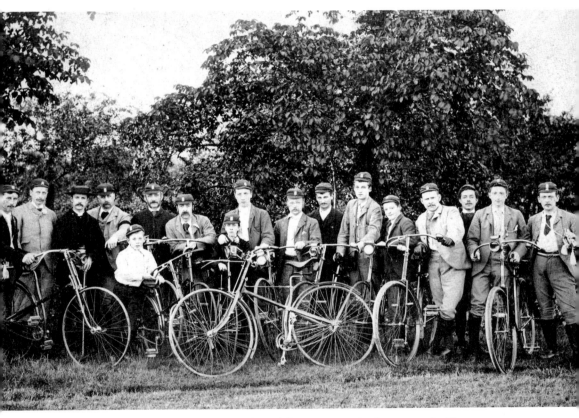

Thirsk Cycling Club, 1892. Victorian cycling clubs were organised on a quasi-military pattern; when riding as a club, the members took their orders from a captain whose commands for manoeuvring were transmitted by a bugler. Left to right: T. Turnbull (sub-bugler), J. Storey (captain), the Revd E. S. DeCourcy Ireland (vice-president), J. E. Myers, Master Amos, C. Mills, ? Mothersill, Master Stott, R. Tose (hon. secretary), ? Skipper, J. W. Jackson, H. Meynell, H. Wright, C. M. R. Knaggs (vice-captain), R. White, J. Ruecroft, ? Scott (bugler).

Hurworth Hunt servants, early 1920s, When Mr Dorrington of Kilvington Hall became Master of Foxhounds to the Hurworth Hunt in the 1920s he brought the kennels down to Kennel Farm between Cowesby and Kirby Knowle. On the extreme right is Jack Howsam who came to Yorkshire from Lincolnshire after the First World War.

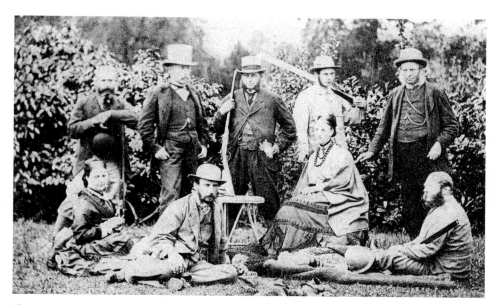

Shooting party at Thirsk Hall, 1872. The male line of the Bell family, lords of the manor of Thirsk, failed in the early years of the nineteenth century and succession was through the daughters. Frederick Macbean, standing extreme left, took the surname Bell on succeeding to the manor in 1850. The remaining standing figures are Major Charles O. Sanders, E. H. Turton, Henry Smith and his father, the Revd H. Smith. Seated are Elizabeth Smith, her brother Reginald, who also took the name Bell and was squire of Thirsk until 1930, Jane Sanders and William Payne-Gallwey.

Guest sportsman at Sunnybank Farm, 1920s. The identity of this visitor to the farm at Carlton Husthwaite is unknown, but he seems satisfied with his bag of a pair of rabbits. (*John Butler*)

Thirsk Athletic Sports, 17 July 1907. The runners are on their marks, but the two men in the outside lanes clearly prefer a standing posture. The staggered positions of the competitors on a straight track suggests that a handicapping system was operating. The stand of Thirsk racecourse can be seen in the background. (*Ray Ballard*)

Motorcycle racing on Sutton Bank, *c.* 1910. The one-in-four gradient and treacherous bends of the road up Sutton Bank made a challenging course for motorcycle races. Thrills and spills aplenty were expected by the crowd gathered at this bend in the route. (*Ray Ballard*)

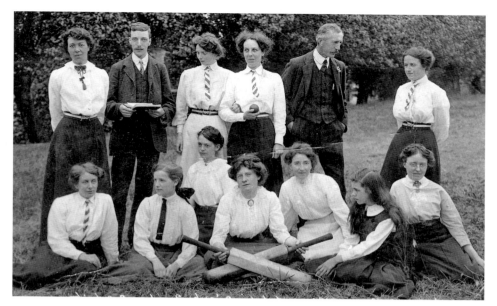

Thirsk and Sowerby Ladies Cricket Team, 1912. No details are known about the members or performance of this team, though Miss Bel Whitteron is recognisable holding the cricket bats in the centre. The long skirts must have made for slow action between the wickets and in the field.

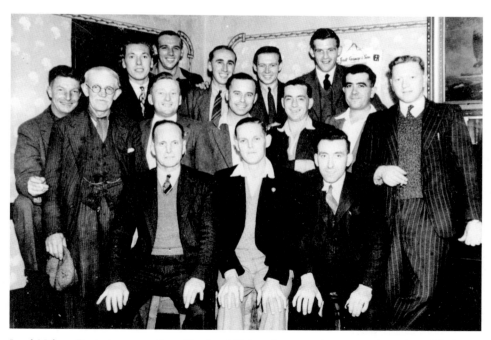

Lord Nelson Darts team, 1948–9. The Lord Nelson is a popular venue, the only public house remaining on St James' Green. Back row, left to right: Bob Rymer, -?-, Jack Renison, Sid Stuart, Henry Sleights. Second row: Bill Drake, Frank Rhodes, Bill Gale, Fred Garthwaite, Herbert Davey, Jim Bradley, Ted Sutcliffe. Front row: Bill Kettlewell, Don Kettlewell, Jeff Coates.

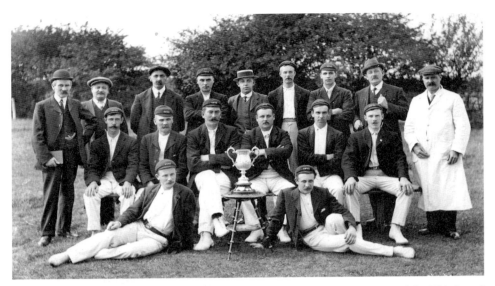

Thirsk Victoria Cricket Team, 1911. The trophy shows the team are winners of the Thirsk and District League. The Crossley brothers were twins who joined up together, served together in the Kings Royal Rifle Corps and died together on the Western Front in 1916. Back row, left to right: R. W. Minican, T. Fuzard, A. Wright, J. Watson, A Mayne, C. Holmes, -?-, K. Dale, -?-. Second row: -?-, ? Kitson, J. Blakey, G. Dale, J. Bradley/Young. Seated: I. Crossley and W Crossley.

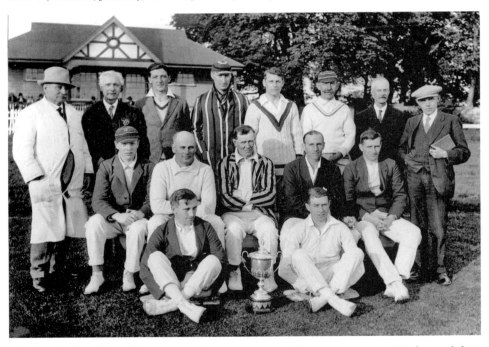

Thirsk Athletic Club 1st XI in 1927. One or two names from 1911 reappear. Back row, left to right: L. Ryder snr, T. J. Lynch, E. H. Jackson, H. D. Phelps, L. Ryder jnr, E. G. Norman, C. H. Holmes, A. Mayne (scorer). Second row: E. L. Gill, T. A. Brooke, F. D. Fawell (captain), H. Arkle, H. M. Lister. Seated: J. M. Lister and H. Walker.

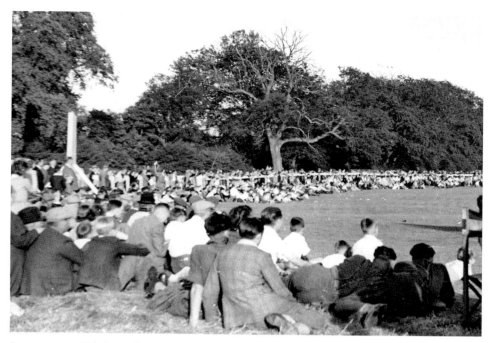

Spectators at Thirsk cricket ground, 1947. The game in progress was a match with Herbert Sutcliffe's XI, which brought a number of well-known Yorkshire and England players to the local ground.

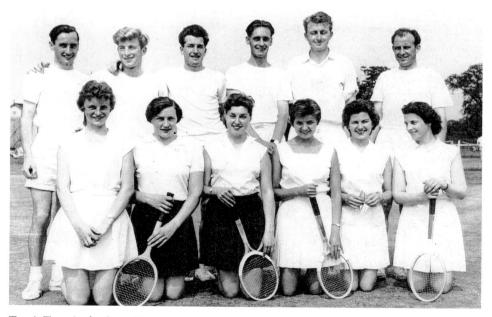

Tennis Team in the Open Tournament 1955. Standing, left to right: Brian Smith, Michael Skipsey, Charles Smith, George Smith, Peter Furness, -?-. Kneeling: -?-, Mary Smith, -?-, -?-, Rhona Dodsworth, -?-.

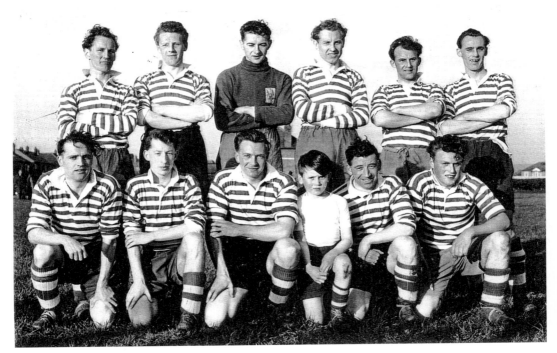

Thirsk Falcons AFC, 1955. Standing, left to right: Jeff Almack, Monty Knowlson, Malcolm Douglas, Ron Armstrong, Alan Chipchase, George Smith, Kneeling: Gordon Freak, Ken Hodgson, Bob Smith, Jeff Almack jnr, Johnny Coates, Jeff Shepherd.

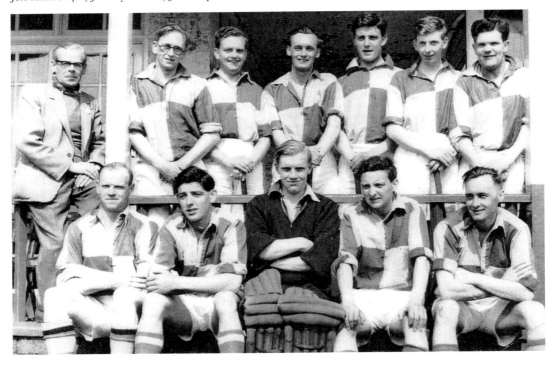

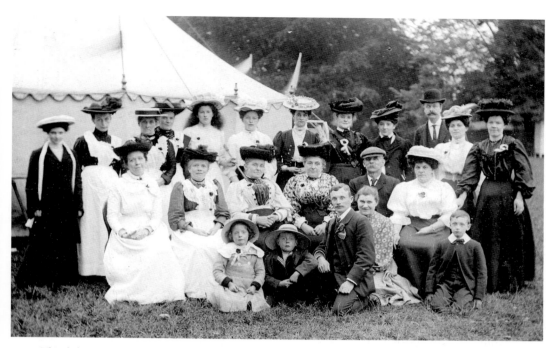

Thirsk historical play, 1907. The historical play was a most ambitious open-air production performed as a fundraising event in the grounds of Thirsk Hall. This pageant, with music specially composed by organist Arthur Todd, told the story of Thirsk down the ages; its large cast included a number of the leading citizens of the town. Among the many pictures of episodes from the play and individuals in costume is this one of the backstage helpers. (*Ray Ballard*)

Opposite: Thirsk hockey team at the Bridlington Festival, 1957. Standing, left to right: ? Scott, Bill Rukin, Peter Dawson, George Smith, Richard Jackson, Brian Dawson, Bill Addison. Seated: Jim Ingledew, Edward Jackson, Jimmy Lister, Chris Jackson. Frank Smith.

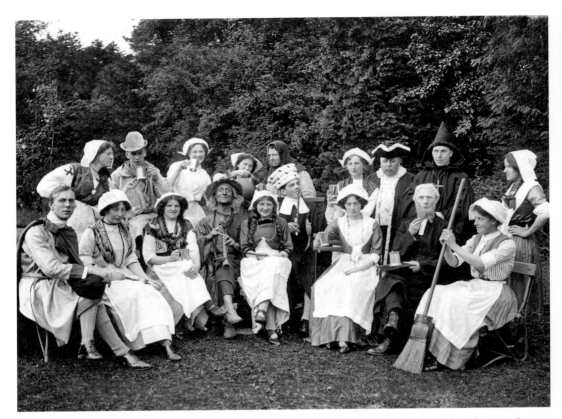

The Pied Piper of Hamelin, performed at the Thirsk Rose Show in 1912. The success of the historical play encouraged some of the participants to present another open-air event some five years later. The Rose Show included the crowning of a Rose Queen, dancing by various groups of children and a version of the *Pied Piper* with adults in the main roles and a chorus of children and rats. Here the adult members of the cast are pictured in a convivial pose.

Opposite: The Amateurs Show, 1951. The figure in the centre is recognisable as Alfred Rutherford, who played leading parts with the Amateurs for a number of shows, both before and after the war.

Thirsk and Sowerby Amateurs, 1948. The Amateurs were formed before the war and had put on several musical comedies popular in the 1930s such as *Miss Hook of Holland* and *Floradora*. They reformed after the war with Fred Scott as producer and put on a series of musical revues. This 1948 scene is not named, but the figure of Queen Elizabeth suggests that it is an excerpt from *Merrie England*.

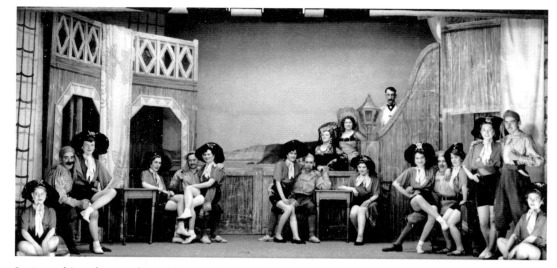

Lyrics and Laughter, performed in 1949. Among those appearing in this show were Audrey Clarkson, George Claxton, Rhona Dodsworth, Peggy Finch, Derek Marriott, Margaret Sheldrake, Brian Smith, George Smith, John Smith and Jill Turnbull.

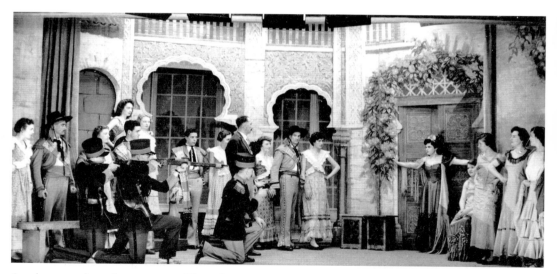

Another scene from the same revue. These shows were noted for the standard of the stage settings which transformed the small stage at the town hall.

Fantasia and Frivolity, March 1950. Members of the cast in a Cockney number as Pearly Kings and Queens.

Finale of the 1950 show. Back row. left to right: George Claxton, -?-, Ronnie Barron, John Smith, -?-. Marjorie Stott, Cliff Crosby. Third row: Phillip Lassy, Mildred Lassy, Ray Palliser, -?-, Alan Steel, -?-, Frank Smith, Hilda Baines. Second row: Barbara Johnson, Fred Scott, Mary Harker, Wendy Turnbull, Alf Rutherford, Mavis Almack, Cliff Williams, Margaret Rose, Edith Bowman, Harold Greenwood, Margaret Jackson, Peggy Kinch, Winnie Cawood. Front row: Betty Barron, Pat Falkinbridge, Margaret Brown, Betty Kay, Jill Turnbull, Mary Smith, Margaret Robson.

Acknowledgements

Acknowledgements are due first of all to the Trustees of Thirsk and District Museum Society who are the titular holders of the Thirsk Museum collection. Three of those trustees have contributed to this present publication: Dr Peter Wyon was co-author of the first book on Thirsk in this series, and many of his own pictures have found their way into our archive. Peter Hatch has also added to the museum's store of prints and has provided useful historical notes, while Ray Ballard has been most generous in allowing me to draw on his personal collection of postcards. John Butler of Carlton Husthwaite has offered some informative snaps from his family album and Maurice Sanderson of Skipton-on-Swale contributed some little-known pictures taken while the RCAF squadrons were based on the airfield laid across the land farmed by his family. I am indebted to former rector the Revd Eric Norris for his donation of a box of nineteenth-century lantern-slides, Edward Barker for a previously unknown early photograph of the family at Thirsk Hall, to Margaret Hunton and Dorothy Ashall for photographs from the 1950s, to Terry Barker for material on Bamlett's, to Mo Penson for the picture of the Crown Inn, to the Smith family for sports teams and scenes from the Amateurs' shows, to Cynthia Wigmore and the late Mrs M. Garner for family portraits and to all those many people who have deposited pictures with the museum and helped to preserve a record of the past for future generations. Finally, I owe a great deal to Margaret, my wife, who has offered advice, criticism and support throughout the final stages of preparation of this book and who has shown remarkable forbearance at a time when every surface in the house has been littered with photographs!

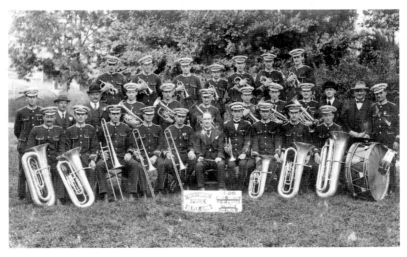

Thirsk and Sowerby Prize Silver Band, 1926. (*Ray Ballard*)